HOW I FIND HER

a mother's dying and a daughter's life

HOW I FIND HER

a mother's dying and a daughter's life

by

Genie Zeiger

May, 2002

For Ruth

Bright Words Always!

Genie Zeiger

SHERMAN ASHER Publishing

Book Design: Judith Rafaela
Cover Design: Janice St. Marie
Cover Image: Family archives

Permissions and acknowledgments:

Lyrics of "*Oh, What A Beautiful Mornin'*" by Richard Rodgers and Oscar Hammerstein II Copyright 1943 by Williamson Music Copyright Renewed International Copyright Secured All Rights Reserved Reprinted by Permission.

Lyrics of "*There's No Business Like Show Business*" by Irving Berlin Copyright 1946 by Irving Berlin Copyright Renewed International Copyright Secured All Rights Reserved Reprinted by Permission.

Lyrics of "*Sunrise, Sunset*" by Sheldon Harnick and Jerry Bock Copyright 1964 (Renewed 1992) by Maylering Productions, LTD. and Jerry Bock Enterprises All Rights Reserved Reprinted by Permission

"17th Psalm" from *A Book of Psalms* by Stephen Mitchell Copyright 1993 by Stephen Mitchell All Rights Reserved Reprinted by Permission of HarperCollins Publishers, Inc.

Library of Congress Cataloging-in-Publication Data

Zeiger, Genie
 How I find her : a mother's dying and a daughter's life / by Genie Zeiger.--1st ed.
 p. cm.
 ISBN 1-890932-16-7 (alk. paper)
 1. Zeiger, Genie. 2. Parent and adult child. 3. Mothers and daughters. 4. Aging parents. 5.Mothers--Death--Psychological aspects. 6. Women poets, American--Family relationships. I. title

HQ755.86 .Z45 2000
306.874'3--dc21

Sherman Asher Publishing
PO Box 2853
Santa Fe, NM 87504
Changing the World One Book at a Time™

For all the caregivers,
visible and invisible

especially Judith Bonilla, Peggy McGuire, and Uschi Rhinehart; Hannah Lively, Chris Martin, Joan Ward, Susie Chandler, Claire Johnson and Aggie Mitchkoski at the Buckley Nursing Home; Jean Footit at Hospice of Franklin County.

Thanks also to my sister, Susie Zeiger, my children, Mara and Josh Silver, and especially to Bill Ennen who, as usual, quietly saw me through. Gratitude also to those who generously helped guide and encourage this book to completion: Nina Ryan, my agent who first believed in this book; to Ellen Patrick, Carol Edelstein, Anna Viadero, Susie Patlove, Robyn Oughton, and finally, Nancy Fay, editor par excellence.

For My Mother at the End

If I give you something
to take with you, let it be

these words, their issue,
for with them I have held

much of what I love:
I have tamed the lion of my heart,

the sparrow of my fear.
I've made of them the city

we knew well: the soft eyes of cars
on the highway, Chopin through

the neighbor's door. And food
of our table, and desire never served.

There was a star you pointed towards
as you held me and said, *star*.

You gave me words, now take
them back, swim your strong crawl

as you did when I watched you
small from shore. Take them all:

lion, sparrow, city, car
door, food, mother, star

As a child, I always had the same dream: I am standing alone on a little shelf, a ledge on the side of a rocky cliff abutting the sea. Towering waves approach me; they are relentless and untiring. I am afraid— I know they want to hit, drench and change me. But into what? I had no idea. And I had no idea how my mother, whose waters I first grew in, had taken up lodging inside me, how our lives had mysteriously fused, one into the other, how in some wet place they had merged, how it would take her dying for me to swim out into something holy, vast and my own. How hard it would be.

Because she is sick and old now, my mother performs the Sabbath ritual very slowly. Sitting down in front of the brass candlesticks given to her by her mother, she looks as if God is pressing down hard on the top of her head. Her face juts forward, and the top of her back is rounded. Because she is demented, and her short-term memory shot, it's impossible to have a conversation with her. But she does remember some things, such as who I am, and the *barucha*, the blessing for the Sabbath, both in English and in Hebrew. Sometimes she remembers where she is: "at Peggy's," a nurse who cares for the elderly in her home about five miles from my own. And because Mom is mostly out of her mind, after the prayer she continues talking to God intimately, without the conventions by which she governed this world daily.

"God," she says, "thank you for my children and grandchildren." She tries to say all our names, but I have to help her with the grandchildren—*Ben, Rachel, Mara, Josh.* She thanks me. "God," she says, "I'm happy for you and may my children also light candles for you and thank you, and may you teach them." She rambles on and on, thanking and imploring, sometimes making sense, often not. It's as if she's thrown a private birthday party for God, as if she knows times are hard for Him, and He needs something to lift his spirits. "Now God," she continues, her hands cradling her face, "I want to give you eighteen kisses." (Eighteen is *Chai,* the Hebrew word for life.)

The candles are scented, and the rush of pine fills her little kitchen. She begins kissing and counting—"one—two—three"—after eighteen she says, "and here's one for good luck—good luck God, and may my children light candles." Then she shmooshes a really long one onto her fingers, which have clearly become in her mind, God's own flesh. As for me, I'm like some Hindu goddess with all those arms, and every arm is a thought or a feeling:

She's cute—no that's condescending, she's ridiculous—no she's child-like, pathetic, No she's like

the Buddha, enlightened, she's my mother, I'm her mother, she's God's daughter, am I her daughter? God help me.

A folded piece of white lace is bobby-pinned to the top of her head. I helped her attach it to her hair, all sprayed and stiff like a dry nest. She is small and forever sitting at the feet of these candles, which are so sweet smelling and golden that even Solomon, I think, in all his glory could never have conjured this scene. Wax drips onto the white Formica of her small kitchen table, and I pick it off with my nail as I listen to her go on. I don't know where to look anymore, exactly what to do; it's as if I'm freeze- framed in some old religious painting, but it's Jewish and confusing—my Mom could be Jesus and I Mary lamenting, not at her feet but sitting beside her flanked by a humming refrigerator and a counter with a microwave and a toaster oven.

At last she takes her hands from her face and looks at me. Her eyes are soft behind her glasses, which have slipped down her nose. I push them back up for her. Her hands are trembling from the Parkinson's. Looking down at them, I think how I really ought to light Friday candles in her honor after she is dead.

"I love you so much," she says. Since she's become demented, she's a geyser of love, all criticism and demand entirely dropped away. I've been grieving for her for almost two years, but for the first time I let myself cry in her presence. When she asks why I'm crying, I can't tell her. What should I say? "Because your body is useless, and you can barely walk? Because you fell last week and lay on the bathroom floor in a mess for hours until someone found you." I can't say, "I am crying because your mind is gone and you can't remember a damn thing, and I don't know what to do; because sometimes you say such stupid things that I'm embarrassed to be your daughter: you say Frank Sinatra is my father, and ask where I am when I'm sitting at your side." I can't say, "Because I'm afraid I'll be just like you, and my kids will suffer as I do now." I can't say anything, so I say, "I don't know," and sob.

She says, "Come here," and I kneel at her side, wrap my arms around her waist and think, *I'd better stop this*, but I can't,

and she begins to cry too, just a little, and I feel her body rigid with Parkinson's, tremble a bit, and she says she wants to kiss my tears and I let her. I feel her soft, scary lips slurp my cheeks and I want to stop this melodrama, this real pain.

When I can't stand it any more, I say jokingly, "Mom you'd better stop tasting my tears, they're salty and you'll get high blood pressure."

She stops and smacks her lips trying to taste better, then says, "They're not salty at all."

"Of course they are," I say, "all tears are salty."

"No, they're not," she insists and raises a finger shakily to her own eye, then lowers it. "Here taste," she says, "see if mine are salty." Her finger is dry and now there's some mascara on it.

"No," I say, "no thanks, I won't eat mascara, see the mascara."

She lifts her finger and stares at it, then shrugs. The candles illuminate her face. I rise from my knees and sit down next to her at the table again wondering what in the world comes next.

2

Next time, we'll go for a drive; it beats sitting around in her apartment. I'll pick her up at Peggy's—this will take at least fifteen minutes— and then off we'll go. I will drive and she will look for her keys. She can't remember that she no longer has keys. I will keep my eyes on Interstate 91 and try not to watch her digging around in her faded blue leather purse. If I tell her she doesn't have keys anymore, she'll get upset. But if I say nothing, she'll continue to fumble and miss the beautiful foliage I've taken her out to see.

"Mom," I lie, "I have your keys, you don't have to look for them."

"Oh?" she says.

"Yes, I have them. Why don't you just relax and look at the trees?"

She makes one more slow pass of her right hand into her bag, then sighs and looks up.

Although the car is going the speed limit, just raised to 65, the trees are distinctly visible, their colors varied and astonishing.

"I like the orange ones," she says.

"Me too."

The silence grows heavy. My mother never liked silences, and I am her child; when I'm with her, resting with their delicacy and openness is not enough.

"The speed limit is 65," my mother says. "See the sign? 65."

"Yes," I say, and hit the button for the radio. Dvořák.

"That's my station," she says. The music helps us out a little. I try to hum along with it, that helps a little too.

"Do you want some gum?" Mom asks.

"No thanks."

Then she's back at her purse, trembling. Parkinson's, a chronic disorder of the central nervous system, causes muscular rigidity and tremor; the required messages for movement, the dopamines, are no longer forthcoming from the brain. There is no definitive cause of the disease, and it is not typically accompanied by mental deterioration.

Again I try to keep my attention on the road, on the bright trees rather than on her hands which are so sadly struggling again in that purse. It has compartments, it has zippers. I can't help thinking I hate that purse. Inside it are a few coins and several old yellowed envelopes, one of them containing her mother's birth certificate, *Mary Schildkraut, 1885, b. in New York City, parents b. Austria.* Another contains a poem written by her father.

My mother is bent over, listing to her left and towards me as I continue to drive. Finally she extracts an old flattened

package of gum, then spends another five minutes unwrapping half a piece. The foil is stuck to the flat, dry *Juicy Fruit*. It is all in slow motion in contrast to the car's speed and the red, orange and gold flying by. The top of my Mom's head is white and gray. Her hair is wiry and alive. Her pink and white sporty pants and blouse set is clean and spiffy, thanks to Peggy.

"Do you want some gum?" she asks again.

"No, thank you."

At last she gets it into her mouth. Then more silence.

"That sign says Greenfield," she offers.

"Uh huh."

"Where are we going?"

"I'm bringing you home."

"Oh," she says.

As we get closer to Peggy's, the road narrows and turns to dirt. Trees move closer.

"What is that?" My Mom asks as we pass a stand of white birch.

"That's birch," I tell her.

"Sounds like bitch," she says.

"That's true, I hadn't thought of that."

"Bitch. Birch. Bitch. Birch..." she repeats. Then a long, long silence. Then "Bitch. Birch. Bitch. Birch. I won't remember anyway," she adds.

She is so slow and addled now, I pity her. It is hard not to hate her sometimes. The feelings in me pass as quickly as did the numbered mile markers along the highway—grief, rage, love, compassion—these now common phantoms rise and fall, rise and fall, and I watch them with awe. I am as astonished at their power as I am by the beauty of these trees: the russet oaks, the blazing maples of New England. The radio is now playing Bach and my mother asks again, "Where are we going?"

I tell her again, and then silence.

"I haven't seen Genie for a while," she says. (I am Genie.)

"Oh, really?" I say.

"Yes," she says with conviction. "She lives somewhere near here, I don't know where."

"She is close by," I say, " you'll see her soon."

"I hope so."

When we get to her apartment, I pull up on the grass as close to the door as possible. I get out of the car and walk around it to help her out. I've learned this ritual. I have learned exactly how many steps there are to get one body out of one car and there are many. First unstrapping her seatbelt, then mine, then opening my car door, then hers, next helping her swivel a little so that her legs are facing toward the door, then placing one of her feet on the ground outside the door with my hands, then instructing her to put the other beside it, then getting both of them flat on the ground, then telling her to apply weight to the legs so as to lift her body toward standing. Then standing, then getting the feet to move—right, left, right, left—my voice acts as a cue for her as she holds tightly onto my arm. In a flash I imagine all the intricate patterns of movement I re-enact daily without thought.

When I leave her with Peggy, there's the awful feeling again, a betrayal of family closeness and endurance, something I can never talk or write myself out of, a strangeness that I am not her Peggy now. Sometimes a similar feeling arises when my grown children leave my home for their own. "Where in the world are you going?" I almost want to ask. But we are, all of us, in motion: both away from the past, and toward it.

≈ 3 ≈

Rewind the camera back twenty years: my father has retired and he and my Mom have moved from New York to southeast Florida, the Jerusalem of the new world for lots of Jews and Italians. A condo, of course, Wynmoor Village: palatial, Disney-like, with low white walls surrounding

miles of two and three storied white, terraced buildings. Artificially made lakes with plastic swans, streets with names that deny connection to the old country—Coconut Creek, Antigua Way, Bahama Circle. Forget the past, be at the movies full time with all the players over fifty-five, (the minimum age required to live there). Beat death with dreamy scenery. Hire guards to stand at the entrances.

Black people were allowed in only to clean and landscape, but my parents never mentioned this, a policy so contrary to what I was taught growing up. My father was adamant about civil rights, and treated Cynthia, the black woman who cleaned for us twice a month, as if she were the Queen of Sheba. Cynthia, a shy soul, would look down at the Chinese rug when my father shook her hand in greeting. Or picture this: I am playing with some neighborhood kids on the block, choosing up sides for stickball. David Minton is in charge, he's doing *eenie, meenie, miney mo*, and just as he gets to the *nigger* part, my father, arriving home from work, walks up the street towards us. "Don't say *nigger*, it's a very bad word," I say to David as Dad moves within earshot, "just say robber." Dad stops and smiles down on me, like God. "Atta girl!" he says, patting me, "I'm proud of you." Forty years later and I can still feel the good touch of his hand on my head.

Before the move, my mother had to leave her job as a head start teacher, a job she loved. She was sixty years old. In a photo of that era, I see her smiling and alive in a room plastered with children's art. Her blouse is of a complex pattern, almost mosaic, hippie looking, her eyes are on fire. All of her is smiling.

While visiting southeast Florida, filled with retirees, I always noticed the extraordinary efforts made to keep disorder and death at bay. Men and women dressed to the nines in pastel outfits highlighting their cultivated or golf-induced suntans. Beauty and clothing shops in abundance between the neatly groomed housing complexes. Everyone working at looking as good and as well maintained as their dwellings. Yet even if your hearing were poor, you knew death was always closing in. There was, for example, the persistent wail of an

ambulance carting the unfortunate from home to one of the many local hospitals. Often I'd see these same ambulances at accident scenes on the well mapped-out roads tediously driven by people with advancing cataracts. Bits of glass would frequently glint on the tarmac, which extends from mini-mall to mini-mall full of restaurants and huge chain drug stores. Entering a deli or drugstore with my folks, I'd see a prairie of white heads, faces often draped with oxygen tubes; walkers and canes everywhere.

During one visit, a hurricane down in Miami sent some tremors further north to Wynmoor. I walked alone in the excitement of the high winds and warm rains, passing dozens of windows through which I saw folks sitting in their living rooms glued to their TVs watching the storm. It seemed an apt metaphor for the restricted life of the old who move south to die.

Having spent a decade and a half of a relaxed "seniors at summer camp" kind of life—dinners with "the barbecue group" (a group of couples who ate together near one of the swimming pools weekly), Hadassah meetings, bridge, early bird special dinners, local theater productions—things had changed for my mother. It was hard to say what exactly. A clumsiness. A weakness. Her strong arms seemed to dangle less defined. She began complaining about my Dad—*he's always criticizing me, he embarrasses me, your father, he won't let me write checks for charity, he's always watching me, your father.*

"Your father," she said, as if he were no longer her husband.

One summer, to escape the Florida heat, my parents were in Wisconsin at an Elderhostel studying Shakespeare. She called me, "your father," she said, "he stands around in the lobby here and talks to people. I hardly see him. Your father keeps criticizing me, he's after me." She reminded me of my sister complaining about *me* when we were kids.

"Mom," I finally said, "let me talk to Dad."

"Okay, I'll get him."

My heart thumped in my throat. My father was not someone I ever spoke to about "real" things.

"Dad, " I said, "Mom says you're mean to her. She's told me this so often that I'm concerned. What's going on?"

"I'll call you back soon," he said and hung up.

Ten minutes later the phone rang. " I brought your mother up to our room." *Your mother.* There was a long pause. I stared out the picture window of our house at the white pines in the distance. They were too close.

"You have no idea what I'm dealing with," he said at last, "no idea."

"Tell me," I said.

During the long silence that followed I thought, *this is the beginning of bad.*

"She can't remember things, she's so slow. I'm always covering for her—at bridge games, at the barbecue group. It's terrible."

"Is there anything I can do?" I asked.

"Nope," he said immediately, "not really."

For a while we chatted around the edges of this kind of sorrow, too large for our words. Then we hung up, and I pictured him *kibitzing* again in the lobby of that dorm in Madison, my Mom sitting nearby confused. My own fortress of "Mother and Father," the one I'd always counted on, had been stormed; in some way, I realized, I was no longer safe.

Later I thought about my father's enduring loneliness—too caustic to have close friends, too edgy for comfort, too poor to rub elbows with the other guys who'd "made it." My mother told me, years after I'd married and left home, that Dad had once lost a job and, afraid of worrying her, he'd dressed and pretended to go to work for two months. When at last he landed a job, he explained it all to her. He was that alone, that foolish, that brave. Now look where he was.

He never spoke of my mother's illness again. Yet something was broken, their private bond, their subdued endurance, their *make-do-ness* and loyalty. His saying, "You have no idea" contained every idea—a fire was blowing smoke through our family and I could smell it.

We were in a Chinese restaurant in New York. My first husband, Charles, and I already had two children, ages three and five, and were in the process of getting a divorce. We were also about to leave for another state, Massachusetts, and another life. Although we hadn't said anything, my mother sensed something big was wrong. The silence at the table was palpable and tense, and no one was admitting the obvious as we ate our last meal in New York together. The kids were oblivious, enchanted by being somewhere new. Josh, his round, greasy face smiling, hit the top of his high chair with a spare rib he'd just finished gnawing, while Mara drew an intricate picture of a house with a red magic marker on her placemat. My mother's mouth was twitching, I'd never seen this before. I kept glancing up at it as I picked at the Lo Mein and Charles ate, somehow, with gusto. But he wasn't making conversation, and he always did.

Our family was about to self-destruct, and no one could help it. As Jackie Gleason said on *The Honeymooners*, "It's bigger than both of us." It was bigger than all of us. The next day on the phone I told my mother about the divorce. I imagine her devastation. She had, she thought, done everything the right way. None of her other friends' daughters were getting divorced. What would they think of her? What would become of her grandchildren? And yet I can't help but imagine a bit of envy on her part, that because of greater economic security and the social changes of the sixties, her daughter could, even with children, escape from mere personal unhappiness. No one in her age group, she had explained to me more than once, got divorced unless her husband was a drunk, or beat her. Yet I knew that although she and Dad went through the rituals of a good marriage, they had taken divergent paths, particularly in terms of how they perceived the world, and the emotional gap between them had ballooned. Habit, need, and loyalty now married them.

Having had to work from the age of fifteen, Dad never got to college for the degree that would have meant more solitary work, accounting, which he enjoyed and would have provided a salary confirming his worth. He was frustrated and

confined by my mother's beliefs and principles—her injunctions to be "nice," to purchase this and that, to conform, to keep up. He expressed his discontent in unending petty and often acrid commentary on the world around him; powerful men—doctors, politicians, lawyers, often rabbis—were his major targets, "those phonies."

There were many undelivered notes she wrote to him about his "negativity" which I found as my sister Susie and I packed up their house years later. I still wonder if she ever acknowledged her fall from the grace of loving him; I don't think she could have denied it entirely.

After I told her of my decision, she said, "Don't think you can move back here with the kids." I said nothing. The truth was I'd never consider it. I was about to move away, I thought, from my beginnings.

When we moved north, so many things changed and so for guidance, I consulted an astrologer. When I walked into his office and took a seat, he looked down at my chart, then up at me and said I was a writer. "Are you writing?" he asked. "Not much," I said, "mostly journaling, but I've always wanted to be a writer." I told him that for a fifth grade composition entitled "My Ambition," I'd written that I wanted to be a poet, and included a poem called, "Come Dear Child," which ended with the memorable couplet: "For you are full of so much charm, that to you will come no harm// not even from a tiger, for you are the daughter of Mr. Zeiger." The astrologer predicted that I would write and publish; he advised joining a writer's workshop, which I did. It was in that workshop that I began writing seriously, that writing became the fire in my body, in my life. Five years later, my first collection of poems, *Sudden Dancing*, was published.

Mom was proud, told all her friends about the book, and she and Dad flew up from Florida for the publication party. The reading was well attended by friends and community, row after row of known faces. But four in particular. My father, sitting erect, his glasses atop his slightly crooked nose (he'd broken it falling down the steps of a library when he was a kid in

Brooklyn), tears dotting his face. My mother beside him, rigid, a thin smile. My kids, even more rigid with the expectation that Mom would, in her singular fashion, embarrass them again, like she did when she'd worn long skirts to their school concerts. These faces in a row, four lighthouses in a large sea of others: the two who had preceded me, and the two who would come after. And what, I wondered later, are any words really compared to the fact of our being here?

Then signing book after book with a new fountain pen. Dancing at the party that followed. My father sat beside the refreshment table flexing his wise guy muscle, happy to talk to someone, he said later, other than a senior citizen. He would explain to whomever would listen that as people aged, they grew cowardly and thus more religious. I overheard him telling my friend Tom that he'd converted from agnosticism to atheism at the age of seventy-six. Tom nodded, "That's cool," he said. My mother sat watching people dancing, her eyes sponges, a small smile on her face.

My parents stayed for a few days. I'd given them my bedroom, a wonderful sunporch facing the backyard with the woods in the distance. In order to get to the bathroom, I had to go through their room. The morning after the reading, I quietly opened their door, and found my mother propped up in bed reading my new book with its bright sky-blue cover imprinted with a picture of Hermes. She was crying as I walked warily past her. When I came out, she looked up at me and said, "I'm sorry for all I did wrong, I had no idea you suffered so." Oh, my. I took a deep breath. The heartlessness of art. Of disclosure which lives at the heart of art.

"It was a long time ago," I said. "It's all right, really."

"No, it isn't," she said, and reached up to hug me.

What wasn't all right for her, I knew, was one of my poems, "Bad Sparrow," about my fear and loneliness in the face of my sister's chronic asthma:

We learn the ritual my mother performs
each night, the one that teaches
the healthy not to need. I am lying
in a small grave and I want so hard

some arms to press me next to something
I know, something human.

Mom was in a nightgown as she'd been on those nights when Susie had her attacks. Only now Mom was smaller. Her dyed hair was jarring beside her pale and wrinkled face. The Parkinson's had not yet fully manifested, but there was a sense of it in her pallor, thinness, and increasing rigidity.

I felt ashamed. I wanted to cradle her as I'd missed her cradling me when my sister's asthma awakened me. I wanted to make everything fine, as she had always insisted it was and would be. I didn't want her crying, as she had not wanted me to cry. *I only want you to be happy,* she'd always said.

≈ 4 ≈

As a child I was fascinated by my parents' bedroom. There was both a visible and invisible border to it, that liminal space. What I could see was the threshold, but I didn't know what to call it then. A piece of wood extending the width of the doorway, it created a small bridge from the flooring of the hallway to that of their room. It induced a formality, implying in its intermediary position that a room is, indeed, a space, distinct from others in its purposes and dreams. And I felt that distinction keenly.

My parents' room was one of great importance and everything in it, particularly the furniture, spoke of solemnity. This was where my sister and I were actually made. The bed was of mahogany, with head and foot boards of that grainy, dark wood. On it was, of course, a mattress rather high off the carpeted floor. The bed was meticulously covered by a shiny green bedspread, smooth as an unworried forehead. Most impressive were the tightly rolled pillows resembling huge hair

curlers. They must have been beaten into submission, set together side by side and ordered severely, *Stay!* for they did. The windows were hung with heavy, beige drapes. Across from the bed two bureaus stood side by side. My father's was five uniform drawers high, the tallest at shoulder level. My mother's squat, more complex matching one, had a series of both wider and lower drawers. My father could simply stand and reach for one handkerchief from his pile of ironed ones, pick up one of his pairs of dark, rolled socks, a pair of boxer shorts. My mother, on the other hand, had to bend or kneel to get to her things. She had to get close to the floor, lower her head, curve her spine, expose her bottom, reach in, perhaps uncomfortably, among the panties, bras, girdles, slips, nylons, blouses.It was clear that the world was one in which men were able to accomplish things easily and directly—just reach and pull: put a hat on, button one or two big buttons on a coat, stick a key in the ignition, get anywhere fast. For women, this process was far more intricate and refined. Intricate in that it required detailed steps: being sure that lights were on or off, dishes dried and put away, children in hand, or at school, or off to bed. Refined in that it required subtle body movements: the articulation of a knee, the bend of a back, how one hand could wring the water out of a sponge while the other held a telephone to the ear. For women were also the bearers of words, they were the ones who chatted, who asked about grandparents, sniffles, grades. They were the ones who would call from outside, "Ruthie!" and my mother would rush to a window, look down and say, "Yes?" Communication makes for complexity. There was a lot for a girl to learn.

Life, on the other hand, was made easy, if not more dull because of fathers. Their pants were brown, gray, black or navy. Their shirts were white. Their shoes were brown or black. Except for ties. In this matter, prominently laid upon their flat chests, you'd sometimes see a streak of gold, a circle of silver, and it was as astonishing as the view of the full moon over the highway. Their clothing was boxy, large and of primitive shape: the squares of boxer underwear, the rectangles, flared or straight, of ties, of pants. For women, dressing was a far more

complex matter and required far more time—fitting breasts into cups A,B,C, or D, thighs into stockings, waists into skirts which flared or lay straight, with wide belts or none, selecting slips, jewelry, dresses. And matching, always there was matching.

"How does this look?" My mother would ask, holding a navy and red polka dot scarf to her neck above a white sheath. "Fine," I'd say. "It's white," she'd offer, "after Memorial Day you can wear white, and almost anything goes with white." I wondered about that *almost*, but didn't ask. I knew it was that *almost* which also distinguished us from men: nuance, particularity. Fathers always seemed to know what it was they wanted—a drink, a newspaper, a paycheck, to see a ball game, to go to sleep. I noticed no hesitancy in my Dad's routines, never a moment of anything *almost* that had to do with work, or love. One minute he'd be reading the newspapers, the next he was asleep. Nothing happened, it appeared, on the borders, in the textured in-between's as it did, for example, in my mother's drawers where I'd sometimes sneak and find some small sweet smelling sachets tucked among her panties, and a small plastic case with a circular rubber thing inside beside a tube of jelly; what was jelly doing in a bedroom?

Female lives were braided, tangled like our hair—was it the doing of our bodies? I knew mine would come to resemble my mother's with its curves and secret places. Our talk, that of the mothers and daughters, was also intricate, detailed. Our clothing was complicated not only by shape and color, but by new and shifting styles involving belts, hems and socks of varied lengths. When it came to dress and communication, nothing was ever cut and dried: Yes, this is it! This is the perfect outfit for this occasion, or: this is the right thing to say when someone dies, or tells the truth.

I thought that if I truly knew my mother's dresser, I'd understand everything, and so I returned to it repeatedly when I was home alone. On my knees, I'd lift and touch, then replace her things in order. There was the smell of her in them, and the unwinking eye of my Dad's bureau looming beside me as I refolded things trying to make it look like I'd never

touched them. For that was required too, even for a girl with ideas: to leave no trace of herself in the wrong place.

As a child in an apartment, I acutely felt the interiority of things. My own body, the body of my room, my parents' presences so distinct from my own and from each other, the cage of my sister's chest, which heaved with her chronic asthma. Sounds echoed off surfaces everywhere—the veneer of finished furniture, the curved sides of vases, pleats of lampshades, grain of carpeting, ice of window, thin metal of the blinds. We seemed to constantly glide past things, or else we fell down into them to sit or lie down.

Was Mom bored at home while Susie and I were at school? What did she dream, what lured her imagination past that confined five room apartment where she seemed so busy moving things around, re-arranging, turning wrinkled cottons smooth, making raw things soft and edible, scrubbing, waxing? All that repetitive housework with hardly a view to look out on. No matter how well it was done, no matter how many meetings she attended in the evenings, how was she satisfied?

My father's work took place out of sight. It was well oiled and precise, clock-like and rhythmic, as was mine: eating, washing, going to work or school, visiting relatives, watching TV.

How are we located, what are our coordinates, what measurements indicate the precise center of a child, the place in which her essence lives? If I were sitting at that center now, I'd see that one coordinate was our apartment, for however alien it might have been because of its confinement, it was my soil, my water and my food. Another coordinate was mystery, which, as a city girl, I associated with the forests I'd read about and seen pictures of in books and magazines. I was especially taken with Rima, the forest girl in *Green Mansions,* and imagined myself chased adoringly, as she was, by a handsome hunter. Another coordinate was, of course, my parents: my silent, breezy, and caustic father, and my mother, whose spirit and blood were so fused with mine.

I knew how God created this world; I'd read it in Hebrew school—the first day, the second, how He said it was good;

and I thought it was good too. But the visible world, the one I awoke to, was somehow mildly disappointing, and so the invisible always lured me. Night was more intriguing than day as I lay in bed imagining, watching the play of lights on the ceiling as a car passed and its headlights pressed through the slats of the closed venetian blinds.

Toward the end of her life, my mother had several phrases that she repeated again and again; one was, "I want to cry." This from a woman who rarely cried—it was as if the tears, which she'd stored for more than seventy years, were pressing for release.

Another: "You are so beautiful." This statement issued indiscriminately from a woman who insisted that beauty was dependent upon strictly defined outward appearances. "They just don't wear that!" she said to Mara, who was cloistered in the dark baggy clothing of a self-conscious thirteen-year-old. It was exactly what they were wearing, those teen-agers, but Mara had to change into something else in order to go out for a fish dinner with the family.

"Grandma hates me," she said to me later.

"No, she doesn't," I said. "It's only her idea about having to dress a certain way." I told Mara the story of how, when I was in high school, I'd gotten dressed one morning in a new blue dress with a big white collar and put on matching white sneakers. Mom wouldn't let me out of the house. "You simply *don't* wear sneakers with a dress," she'd said. I knew it had something to do with poverty, with the depression, and I reluctantly changed. When I got to school, my friend Laurie was wearing the exact same dress *with sneakers*. Although she lived two bus lines away, I jumped up and down begging her to come home with me in order to show my Mom her outfit. She did and Mom, shaking her head and *tsking* with the hint of a smile, apologized.

In the end, however, her vision deepened past mere appearances. She perceived the essence behind the face, make-up, hair style, shoe and outfit combinations, saw the beauty

that travels from the heart to the eyes, and needs no adornment.

My mother was never handy, but when I was in high school, she spent several years working on a cross-stitch pattern in white embroidery on a stamped forest green tablecloth. It was repetitive, precise work. It was following instructions, pushing a needle in and out, in and out. It was like those paint by number pictures popular at the time; she completed one, a scene in Paris with a man in a beret, a tree, the Eiffel tower, and a shop with a sign on it that said *Cafe*. It was space defined by imprinted numbers and their designated colors. It was a mechanistic effort to reproduce an ideal world on canvas. But in the end, it was nothing like real life—nothing like what happens when the brain loses its authority.

5

Dutiful and unwavering, she was a good woman, the second daughter of a religious and austere immigrant, Menachem Mendel Greenberg, who left Odessa at the age of six and arrived at Ellis Island in 1907 with his mother, Pearl. As they waited on line at immigration, a man approached his mother and him. This stranger, one Mr. Greenberg, inquired if my great-grandmother had traveled with her husband. She shook her head sadly and explained that her husband died in the old country. The man then proposed that he and my great-grandmother pretend to be married; he'd heard it was easier to get into the new land this way. The agreement was struck: my grandfather and his mother were thus registered as "Greenberg" in America, forsaking *Weitzman* and never seeing the real Mr. Greenberg again.

Twenty odd years later, grandpa met my grandmother at a Zionist meeting where she impressed him with how precisely

she took minutes, and with the fact that she was actually born in the States. She was quiet, dignified, and had long braids that she pinned into a wide crown on her head.

There is a natural, easy alliance between the young and the old. Grandma Mary sat with me for hours drawing pictures of cups, saucers, cats, and dogs. She was short, soft and had time on her hands, unlike my busy mother. When the point of her pencil grew dull, she'd sharpen it with a small knife, making swift strokes away from her body and leaving small swirls of wood edged by lines of orange paint on the blue oilcloth over her kitchen table.

I sat beside her watching in awe as tiny new worlds appeared on paper. When I told her how beautiful they were, the cats were my favorite, she'd laugh, pat my head, and say it was nothing. When I told her how beautiful her braids were as they fell down her back after she took out the long black pins, she'd say, "Oh, no, once they were beautiful, but now they are so thin." She let me touch one braid at a time and I did, stroking each one as if it were a dog or a cat, and loving its bumpy softness. Much later, in a poem, I wrote:

> I lift her
> Thin braid
> Air! Feathers!
> How it travels
> Down her spine
> Quiet
> As a wristbone

Like most grandmothers of her generation, she cooked; she stood at her small white enamel stove stirring soups and making stuffed cabbage. Or she would sit down with me at the table again, the paper and pencils set aside, and we would shape cookies from batter filled with cinnamon and walnuts.

Grandpa became a pharmacist with his own drugstore occupying the corner of a Brooklyn street and shaped like the famous Flat Iron building in Manhattan. The large glass windows displayed huge and interestingly shaped glass containers filled with tinted waters and herbs, symbols for apothecaries then as revolving poles were for barbershops. In one photo,

Dr. Greenberg, (this is what his customers called him), stands stiffly on the top of the three steps leading to the door. He wears his white starched jacket with its clerical collar, the white signifying purity and importance. He was a man who gave a great deal of advice to his customers. A basket of free apples was always on the counter, as was a hand written sign declaring: *An apple a day keeps the doctor away.* In another photo, taken during W.W. II, a sign beside him reads: *Be Careful What You Say, The Enemy May Be Listening.*

Ruth, my Mom, was Grandpa's favorite—not as beautiful as her elder and more rebellious sister, Toby, but sturdy in body and spirit. A young mare with blinders, which he put on to keep her moving straight on the path he prescribed. He hired a private Hebrew teacher for her, and later directed her towards Chiropractic school, a form of healing he favored over the medications he dispensed along with the brochures he himself wrote espousing apples for general health, and lemon juice as a cure for cancer. (He even had his "lemon cure" registered with the patent office, along with a device which automatically sprayed disinfectant inside a garbage can after the lid was lowered.)

My mother graduated from the New York School of Chiropractic in 1937, without a college degree, at the age of twenty. Her diploma, issued in the city of Wilmington, Delaware, contains the words *Tollitur:: Arte:: Malum.*: "Evil is removed by Art." While in training, she was assigned a paper to read aloud to her class. The subject was diarrhea. She loved to recall how she stood up, paper in hand and pronounced it *die-area,* and everyone laughed. The training had been difficult, but she was one in a handful of the first women who attended and received her degree. Then the Depression arrived and she could not afford to open an office.

Although she never practiced professionally, Mom did her chiropractic on us. She cracked our necks—my sister's and mine—whenever we weren't well. She rubbed our shoulders, gently twisted our small spines. Well before the oat bran craze, she believed in the importance of good diet. When the polio scare began, she resisted shots for us until school officials called

home to say that we'd be kept out of school unless we had them.

When we were ill, she entrusted us halfheartedly to Dr. Silverman, the kindly and officious local G.P. who sometimes visited our apartment with a black satchel. He sported a little mustache, had clean large hands, and wore wire rim glasses. Often she entrusted us wholeheartedly to Mark Reiner, a chiropractor. White haired, gentle and elegant, she adored him. She'd haul us to his office in Manhattan, and when we arrived, he'd rub his strong hands together, stare down at us, and say, "Let's make popcorn!"

I'd try to relax on the white paper sheet that covered the high leather table because I knew that if I relaxed, the corn would pop and it would be over. If I stayed stiff (I usually did, I was terrified), then the corn wouldn't pop and the attempted adjustment would hurt and need to be repeated.

I once heard Mark Reiner tell my mother that he took a shower every morning, alternating hot and cold water, how that routine made for excellent health. Indeed, he did look healthy—rosy, trim and straight. Whenever I saw him, I imagined him naked under teeming streams of water, hot or cold, never in between.

My mother was charmed. I could tell by how she moved and smiled. I could tell Mark Reiner loved her. Everything he did was respectful and planned in her presence— how he shook her hand, how he described the showers, how, when he asked after her health, he'd hold her hand in his as if it were breakable. How different he was from Dad, I thought, who showed his affection by grabbing her for a crazy little tango across the narrow length of the living room floor.

Whenever Mark Reiner would ask how she was, Mom said "perfect, never even a cold." It was true. She was always up and about, hair tidy, back straight as she went on doing what was expected without comment or complaint. For example, grooming. She dressed us and herself immaculately. Maybe it had to do with World War II, with how many of our people had been stripped and murdered. And so we were dressed to contradict this: fussed up and down with details, we became

the decorated and arranged antidotes to those familiar looking terrified children in dark coats with their arms raised, to the piles of haphazard shoes, mountains of lobbed off hair, hills of jewelry, which I'd see pictures of when I was older. My sister and I had matching coats and hats for spring and winter. The spring hats were straw and decorated with ribbons or flowers. There was a skinny elastic strap that went under the chin. The spring coats were mostly blue and white checked with navy buttons and trim, a shiny blue satin lining. The winter coats were brown, with fake brown fur trim and matching hats. Shoes to match too, polished.

Order ruled our home and my mother Ruth was our benign czarina. Regular meals at regular times, although the chicken was always destined to be overbaked and dry. After the rare occasion of baking a chocolate cake, and the not so rare occasion of leaving it in the oven too long, Mom inventively took a toothpick, punctured holes in the top of the cake, and poured an entire cup of orange juice over the thing. "To moisten it," she explained.

She was good at salads, green ones, which we ate every evening, for health. Our family had been strictly vegetarian in the forties, but when Dad began resembling a pencil, and I had constant colds, my mother decided to change our diet. She announced to me, I was three or four at the time, that we would now eat chicken and fish. I'd probably never seen a live chicken, but I pointed to the silvery orange finned creatures in the glass bowl on the bookshelf and asked it we could eat them.

There were assigned seats at the dinner table, and table manners. There were also constant infractions. My father, for example, often chewed with his mouth open, or reached across the table for a pickle from the oval shaped cut glass dish. After I listened to the record my Mom bought for my sister and me, *Manners Can Be Fun*, I knew he had things to learn. "Dad," I said, "you're supposed to *ask* for someone to pass the plate, not *reach* like that."

"It's easier this way," he'd say, his mouth full.

My sister, dubbed Sarah Bernhardt early in life by my Dad, threw fits at most of our meals. She was our familial Vesuvius, erupting on schedule and pouring out the darkness and heat the rest of us kept at bay. We'd be in the middle of a dull meal, nothing much going on but *munch, munch, munch* when I'd kick her under the table.

"Ma," she'd scream, "Genie's kicking me."

"Stop it, Genie," Mom would say. Then more dull silence and *munch, munch, munch* again. Another kick and Susie would let loose—she'd stand up shrieking, then parade her skinny body across the living room on into the bathroom, her arms flailing like those of a spastic cheerleader.

Even after she slammed the door, we could hear her shrieks at the table. Then Mom gave Dad the nod. The nod meant that it was time for him to go into the kitchen, retrieve the screwdriver from the odds and ends drawer under the silverware drawer, walk to the bathroom door (which Sarah Bernhardt had locked behind her), insert the head of the screwdriver into the hole in the doorknob, and open it. Then he'd haul her back to the table.

"You must eat," Mom would tell her. She really did need to eat, she was skinny. She'd sit, snivel and munch a little, muttering about the evils of my character. The situation got so bad that my mother wrote a letter to Dr. Rose Franzblau, a psychologist who had a regular column in *The New York Post*. Lo and behold, a few weeks later the newspaper printed a response:

> *Dear Harried Mother in Queens: ...your daughters are trying to get your attention by creating these incidents at the table. Make sure your family members actually talk with each other, ask the children questions about school, their ideas and feelings...*

After that, each evening we'd sit as usual in our assigned seats, but as soon as the platters were passed around and each plate was full, my mother would ask, "So how was your day in school girls?" "Fine," I'd say. "Fine," Susie said. "Tell me more," Mom cajoled, trying to do the homework assigned by her

teacher, Dr. Rose Franzblau, "How are your friends?" We'd make some desultory comments, then the silence would grow, my leg would get itchy, I'd give Susie a good one, and off she'd scream into the bathroom. Then the nod from Mom, then my Dad with the screwdriver, then the door opened and Susie was hauled back to the table.

Mom must have been utterly confounded—she always did what was right for the children, for the family. Such things never happened at her father's table. Did its dark roots travel back to my father's side of the family? Her father-in-law, a carpenter, had died of TB in his thirties. Perhaps if her husband had grown up with a man who modeled a bit of authority.... Carl did little to discipline the girls. Occasionally he'd threaten them with "the belt" he kept rolled up in his top drawer, but whenever he spoke of it, he laughed softly. The girls knew he'd never touch them. Why had she married him?

Mom met and fell madly in love with my Dad, a thin jaunty man with a heart murmur, that kept him out of World War II, and he adored her. I found evidence in the form of letters Mom saved from him written to her when she was on vacation at a vegetarian hotel in the Catskills:

> Says I to me... such a swell good-natured kid.... what a disposition.... if she gets along with me she must be A-one....wonder whether she feels 1/10th for me as I for her..... If I weren't here writing to her, I would be playing cards, my second love.... my first is Ruth....hope she doesn't forget to write me....seems funny.... not enjoying this food... it's the same I usually eat... this lunch has no taste at all....hope she gets back soon....

There was no premarital sex, Mom explained to me when I was an adult: "You just didn't do it." That partly explained to me the "madly in love" statement, but what else was at play? My Dad must have been an antidote to her father's righteousness and rigidity. Carl was a spirited wiseguy, a pool hall devotee, an agnostic, a crap shooter. He walked with a bounce in his step, with an air of freedom, with a Sinatra buzz. Being in

his arms, she was infused by that jitter and the possibility of wings lifting her out of the confines of her father's grasp and into sky the color of my father's eyes. Joining him meant also meant entry into a lively circle of couples with whom they would socialize for most of their lives. In the old photos, there are four pairs of men and women at the beach having a grand old time of it. In one, my mother is radiant as she kneels in front of my father with his fair hair, his wire rim glasses, his right arm lifted in a salute. A scarf is around Mom's head, her dark hair escaping from behind its borders. She wears a halter top and shorts, her eyes beaming as she leans sideways into Julia, her childhood friend. The ocean sprawls out forever behind them; I imagine their words: *Hooray, we're on our way!*

Her father remained adamantly opposed to the marriage. Toby, the older sister, was not yet married— it was not in the order of things; it had something to do with God. She pleaded, he refused. In a letter to her, written in his beautiful penmanship, he explains:

> As you well know, it is simply not proper for a younger sister to marry before her elder sister. This is not dignified, nor is it respectable. Therefore, I must forbid your marriage to Carl, a young man whom I know you are fond of, but about whom I remain, in some way, uncertain. Have you considered the situation over as carefully as you might? Have you searched yourself adequately? After all, marriage is a contract that is serious and has serious consequences both for you and for your future, as well as that of your children. I am extremely troubled by your determination and lack of respect in this regard.

My grandfather managed to delay the marriage for two long years until Mom convinced her mother *to please oh please*, speak to him on her behalf. At last Grandpa relented, and my parents were married at their home. The following year, Toby was also married. Two years later I was born.

Mom told me that when she was in labor with me, she found herself kneeling on the floor of the dark living room in her small apartment pulling on the white curtains with her pain. I see those curtains still—as if they were the clapper of a vast bell that would summon great change, as if they were the veil between the world of the living and the other world waiting to be born, a world without war, without her pain which, I could not help thinking, especially as a kid, was my fault.

On the other hand, I always knew I was her joy, "The light of her life," as she put it, sitting me on her lap with a sigh. I knew she loved me more than my sister. It wasn't just that I was her healthy first child, it was that my looks and temperament were akin to hers. I was dark haired and serious. My asthmatic sister was our father's daughter, blond and blue eyed, as he was. He could tease and jive with her in ways my own nature did not allow. I also knew that my mother loved me best of all, even better than she loved my father. It was a gift and a weight because I knew that the standards she applied to herself had to be adopted as my own. It was difficult to feel separate from her, to know how to find my way without her eyes, to know where to go without her directives, to know how to stand in place when I arrived. But I was a good girl and I tried; I studied her world.

 6

When you are small, mother is big and warm: her breasts, her hands giving as bread, how they hold you and move objects toward you—food, clothing, books, toys, a mirror with your own face whenever you look into it. My mother, believing in the health-giving properties of sunlight, set up a sunlamp for me in a dark Brooklyn apartment. Set a soft blanket on a table under it. Set me on the soft blanket,

massaged my body and let the light warm me. I've been blinded and intensely drawn to sunlight ever since, always moving into a patch of it while others move immediately for the shade.

She put love in my mouth, and language. She was the stem to my flowering. She was my water. In Chinatown, she bought me a sealed up pair of shells that we soaked in a jar of water until one day they opened, and a skinny flower, like a water lily, bobbed its way to the top. My mother was also the lid to my jar, containing me, making me practice piano, dance, come to the table, take a bath, do the dishes. Like the sun, she was on schedule. Rules were rules, and I was a good pupil. She moved and functioned so precisely that even burning the vegetables was an art. Night after night, just enough to scorch the broccoli or beans, to blacken the bottom of the stainless steel pot. Never enough to have to throw out a thing.

If her Kosher home were defiled, if an errant meat spoon accidentally made its way into a bowl of cereal, it would be put into the soil of a potted plant, most often a philodendron, for five days to purify it. She also purified me, extracting questions from my throat before they were voiced. I knew, somehow, she didn't want to hear them, and I needed her approval more than I needed to ask, "Why does God let bad things happen?" or "Why do people die?" I tucked my questions, neatly folded, among my undershirts and underpants until they were forgotten.

Her answers had nothing to do with words, but with deeds. In cleanliness, service to others, in homework, synagogue, in finishing a meal for the starving children in India. Answers were in the cut of my mother's hair, in the styling performed at Ella's, in the dark thickness of her hair, stiff with spray on Fridays and then loosening and softening as the days passed. In the make-up she applied religiously, although more sparingly than most of her friends, when going out in those days of endless Maybelline: eye shadow, rouge, a touch of mascara, the inevitable lipstick carefully reapplied while looking into a compact mirror over empty plates at the end of eating dinner out at the Chinese restaurant.

How do you construct the entire *idea* of a life? How is it possible to configure your own, no less someone else's, much less your own mother's? Think about the vast numbers of thoughts, feelings and ideas that hit you in just one day. Try to imagine a failing parent's life intact. Her ineffable body which, like God's (try to imagine God's body), created your own. Do you look like your mother? Are your bodies similar? Do you sound like her? Will you die the way she does?

I have her dark hair and eyes, her will to do. Like her, my energies quicken when I'm organizing, leading, speaking in front of others. I have her basic shape and critical eye. But my corners are dustier, full of questions and departures.

Sometimes I think I am her shadow self, living the life she forsook, which the fifties, a slow black and white decade, took from her. The great depression and World War II over, her generation sought refuge in security and materialism. Real trouble leads inevitably to silence. Most mothers of her era remained mute when it came to what we daughters name "real things." Our mothers were sitting tight, holding on to husbands, new refrigerators, charm bracelets, sofas, us; they were too afraid to speak truth.

The musicals of the forties and fifties hold the opposing bright side of that silence. They are replete with the best of what a stiff upper lip can offer when it softens into song. The shows my parents loved and played on the hi-fi, so many times that I can still sing the lyrics by heart, have an innocence, a clean and hopeful vitality which is antidote to alienation. Romantic love, family ties, baseball, class conflict are some of the themes in such shows as *Kismet, Carousel, Damn Yankees, My Fair Lady, Annie Get Your Gun.* Listening to Ethel Merman belt it out as Annie Oakley can lift one out of ennui like almost nothing else I hear now, and that show's big production number, *There's No Business Like Show Business*, contains lyrics that could easily be inscribed on the tombstone of the fifties:

> *You get word before the show has started*
> *that your favorite uncle died at dawn*

and once more your ma and pa have parted
you're broken hearted, but you go on.
There's no people like show people
they smile when they are low....
let's go on with the show!

Sometimes I think of myself as a double agent, my
mother's and my own. Her small apartment in the city, my
large house in the country. Her God, *Adoshem,* my eclectic
search for a spiritual home organized from a center within my
own body. Not looking up at a man in the sky, or in the syna-
gogue, as she did, but turning my gaze inward. Or at my gar-
dens (she never had a garden), at the earth. Changing pro-
nouns from *his* (father, Jehovah) toward *her* (mother,
Shekinah), as well as towards my own ideas, my spiritual search-
ing in the company of other women, such as in the women's
group I've been a member of for almost twenty-five years. Her
arrow becomes my circle moving inward.

Once the sixties arrived, arm in arm with my friends,
cheered on by the Beatles, The Doors, Janis Joplin, and a host
of others, I was free to make choices, move in unexpected di-
rections. At mid-life, I'd say I've led more than one life, per-
haps three. She, by comparison (am I being unfair?), appears
to have had one life, and her choices more often made for
her—to believe in one God, to live with one man (often for
worse), to be a full-time mother forsaking a profession as a
chiropractor, to live in one city, and then, upon retirement,
to move to another.

She did not sit and speak about herself with other women,
did not receive encouragement to listen to her self and nur-
ture her own unique being and spirit. Her privacy was a sari
around her, the long delicate fabric of it keeping her from
moving too far. Her steps, like those of most women then, were
smaller, hemmed in by the decade and its fears—the Russians,
the H-bomb, the enemy without.

I imagine her explaining herself to me this way:
I did the best I could. I tried very hard to always do
the right thing. I kept my mouth shut and my back
strong. I didn't want to confuse you and your sister

with emotion. I didn't want to see the deeper shadows under which we lived and so, in not seeing, I turned my gaze above them and made my own machinery. I kept things organized and moving and so we all survived. Had I opened my eyes or heart too wide, the fear would have jumped out and where would we be? Your sister with her terrible asthma, your Dad with his bad heart. Poverty was close before the war. Death was close during and after it, you can't understand.

I used routines as shields, new clothing and jewelry as armor, furniture as props. I protected us and pretended so much that it was no longer pretend. And say what you will of personal fulfillment, of individual freedoms and their worth, I did what needed to be done. And so go on, you go ahead and tell the story. I couldn't trust words in my generation of trusting roles—mother, wife, daughter, community leader, friend, neighbor. We played our roles so well for you kids, we made a secure world for you. So "feel" (that word of yours), feel what you are, what we, your parents, become through you. Without the ground we lay down for you, your good wings are useless. Fly, daughter, fly for me too.

7

I first flew with Lisa. Thirteen and best friends, we hung out every day after school, eating cookies, Pecan Sandies or Jan Hagels, perched on stools at a counter in her kitchen. We drank tall cold glasses of milk into which we dunked our cookies. On the floor below us, Lisa's cats Gus and

Mitzi, ate the kidneys, hearts and livers of other animals. We could hear their jaws and teeth.

My Dad took us both to a rally for SANE, an anti-nuclear group, where we served as ushers. A man, who introduced himself as Walter Reuther, asked us if we would like to meet someone. We followed him into a large room in which an elderly woman sat on a burgundy velvet chair. She smiled at us and extended a thin hand. Her name was Eleanor Roosevelt, and she thanked Lisa and me for being there, for being young people who wanted to make the world better. We did, we shared an outrageous idealism.

I loved Lisa in a way that was holy; what I mean is I thought she was better than I was, the way I thought God was, in the way of aspiration, of yearning to be....Beautiful? Radiant? There is no word for it. But *Lisa,* there's a word. I thought she was prettier, more artistic. I thought her family far more interesting, cultured, Bohemian. I loved the room she shared with her sister, Margo. It had walls of different colors. In her living room were two black canvas butterfly chairs; on the living room walls was real art. A painting, for example, of an Italian Bishop: the deep red of his robe, his hooked, distinguished Italian nose, not a Jewish one like mine. Lisa's mother, Mary worked in Manhattan and spoke Italian. She read *Anna Karenina,* her favorite novel, every year at Christmas, and put little green things called *capers* in salad. She had thin, straight black hair, which was pulled back into a plain bun. Lisa's mother didn't go to the beauty parlor like my mother did, that was *bourgeois.*

It is Christmas time, *Anna Karenina* time, a hard winter with lots of snow. Lisa's mother needs to be picked up at the train station after her day at work at the optometrist's office in Manhattan. She calls Lisa's father, Pete, an artist whose heart is bad. That is why he works at home in a room in the back of their apartment. He draws and paints there, and I hardly ever see him. On that day, Pete walks out to the small Fiat, picks up his shovel, begins shoveling snow from around the car and dies there on the street.

The next day Lisa is not in school. When I get home, my mother tells me that Mr. Barto died. She says that he was shoveling snow. I think: "What about Lisa?" But I don't say anything; death has put up a big blank wall between us and I am afraid to call her, I am only thirteen years old, this strange thing happened to my best friend, and I have no idea what to do. Not a clue. I keep thinking, *Lisa has no father*. I think, *I have a friend without a father*; I think, *I don't have a friend anymore,* she feels so far away.

I imagine her apartment cloaked in black, the black from the two butterfly chairs seeping through all the rooms and staining everything. Lisa's mother in the back, in the empty studio, crying. She is getting even thinner than she was. The whole apartment has become a foreign city and I have no passport.

Three days pass. Finally, I ask my mother what I should do.

She says, "I think it is all right to call her."

I pick up the telephone, my heart pounding.

She answers,

"Lisa?" I say.

"Hi."

Her voice sounds the same. Whew.

"Are you okay?" I ask.

"I'm okay."

"Good."

There is a long pause.

"Do you want me to come over?" I ask.

"Sure, that would be great."

"I have a new Joan Baez record," I hear myself say, "but I won't bring it. I mean...."

"Oh," she says, "my father would want us to hear music. We still listen to music."

She said it, she said the word *father*.

The two blocks to her house are very long that day. The record is in my arms, the way I hold my library books, close to my chest. Joan Baez is very pretty on the cover. I wished I looked like her, or like Lisa.

Lisa's house was different. For one thing, the downstairs neighbor, Leslie Stein, was upstairs going from the kitchen to the studio and back. Lisa's mother must have been back there, but I didn't see her. Lisa took me into her room. She looked the same. The walls were still two colors in her bedroom. Her sister, Margo, was out. We sat on her bed and talked. We pretended that everything was normal, the way we used to pretend we were spies for the good side in a bad war, like the one against Franco for which my Dad said he saved the silver foil lining of his packs of Camels; "for bullets," he explained.

I never asked her about her father, or her mother. We talked of everything else as usual—politics, boys, moods, books, school, but never of that, and so it is no surprise that this story, like the cargo of a sunken ship, the one she and I set sail on together, should have remained buried, and then, as my own mother was dying, it arose to the surface.

The example of our silence in the face of death was, in a sense, conspiratorial. *Don't mention it, and it will go away. Don't mention it, or it will eat you. Don't mention it, or you will die. Step on a crack, break your mother's back*....Magic. Power.

Lisa and I went down to Greenwich village on the subway. We found one of the abundant hand-crafted leather shops of that time and bought matching black belts, very wide belts, shaped like hour glasses that laced in front. The tighter the better. In them we were exotic and curvaceous, slim Bohemians, no longer just two girls from Queens.

"Do you think they're too weird?" I asked. "What do you think your Mom will say?"

We'd just gotten back to my room, and had tried them on again.

"They're great!" said Lisa twirling, looking at herself over her right shoulder in the mirror. Hers was laced over the bottom of a white blouse with puffy sleeves tucked into an olive green skirt.

"Do you think we get enough oxygen?" I asked.

My waist hurt, but it was so beautiful.

"I think so," Lisa said. Then she added, "Do you think it's weird that we have the same ones, I mean it's kind of conformist."

"No," I said, "it just means we're best friends and everyone knows that anyway, right?"

We hadn't yet had the brainstorm—I think I was the one who had it first—that with our black outfits, our belts, our long hair and pale lipstick, we were actually conforming to nonconformity. This was a subject we would discuss endlessly that year.

Lisa and I faced death and each other briefly, said nothing, and went on. But it was different for us and between us. It forced us to leave our teenage Eden with lumps in our throats. Stones, heavy and intractable. Too big to net with words, bigger than a whale. Instead of speaking, we kept strumming our guitars and sang—*This Land is Your Land, If I Had a Hammer, Silver Dagger, The Midnight Special.*

I want to talk to Lisa now, to ask her if she remembers how nice my mother was. I want to tell her how she's even nicer, how she would love Lisa even more than she did back then when she said Lisa was the ugly duckling who turned into a swan. I want to say clearly, " Lisa, I'm sorry that your Dad died; I'm sorry for all our silence."

There is a shield around us in adolescence, and although our minds and bodies are rapidly expanding, we are insulated by something as indomitable as metal. We were so excited by life—our dumb belts, our folk music, our superiority to the ordinary, jerky kids at W.C. Bryant High School. My crush on Scovey—I can still feel the dark wind racing past us as he and I careened down some hill one night on a bicycle, me holding onto his thin upper body, too excited to breathe. Lisa and Bobby Atkins. Our panache, our pretensions, as real to us then as a good sleep or a cup of tea is now. We were a new generation, and nothing could retard our rush into making the world in our image.

After my parents had been in Florida for about a dozen years, I began to notice how much my father was aging. In his early seventies, he'd just purchased new burial plots in Florida to replace those bought up north ("so when we go, it will be easier for you girls"). With his bent arthritic back, and his new difficulty hearing, I began thinking how I didn't remember ever telling him I loved him. What if he died before I managed to say it? Another summer passed, and another; then during one particular visit to our house, I decided this was it. To fortify myself, I drank some Burgundy while Dad read *The Boston Globe* at the kitchen table. I chopped carrots, celery, rinsed lettuce, sipped wine, my heart pounding. I felt like I was about to jump off a cliff.

"Dad?" I finally said, too loud.

"Yes," he answered, still reading.

"I love you," I blurted, the red leaf lettuce shaking in my hand.

"What?"

"I love you," I repeated.

"Oh," he said without looking up from his paper, "Likewise."

While he was in the ICU of a Florida hospital, after a heart attack a year later, my sister, mother, and I visited him daily and each of us chanted in turn, "I love you" as we kissed him before leaving. With oxygen tubes in his nose, intravenous blood thinners, and catheters, he looked look vaguely in our direction and crisply said, "Likewise."

A few days after I returned home from the ICU visit, the phone rang. I picked it up in the kitchen, and walked toward the wood stove, phone in hand. It was December and cold. My mother said, "I never thought I'd ever have to tell you this, but your father died this morning. He was eating a tuna sandwich while he died...." I sank to the wooden floor and sat there

in disbelief as I listened to her. I continued to sit there for a long time after I hung up the phone.

Then down to Florida for the burial.

I remember Mom telling Dad that if he wasn't nicer to people, no one would come to his funeral, but more than two hundred people showed up to send him off (the Rabbi told me later, when I remarked on the size of the crowd, that most of them had nothing better to do).

My sister and I had both written eulogies and held them nervously in hand. The Rabbi asked to see them just before the service as we sat in a small room with my father's casket. Beyond the folding doors, people stirred and talked. I didn't want my speech screened, "It's a fine tribute, believe me, so is my sister's," I said. Finally, the Rabbi explained that family members sometimes say terrible things about the deceased, that friends or acquaintances get up and ask for money, or reminisce about things that have absolutely nothing to do with the dead.

Susie and I reluctantly read our speeches to him, then he nodded his approval for us to do most of the officiating. Toward the end of the service, after I'd read a poem for my father, I tripped as I stepped off the dais. The entire audience, an ocean of white heads, moved forward as if it were a wave to catch me, and in unison this wave gasped softly. Then, as I steadied myself, there was a moment of silence. "I'm fine," I said as I looked up, before returning to my seat.

Afterward, outside the chapel, Artie Gableman introduced himself. Wiry and tanned, a familiar face although I hadn't seen him in at least thirty years, he shook his head and said, "I can't believe it, it seems like yesterday when your Dad and I played pinochle in the back of that candy store in Brooklyn. Your Dad was the best damn pinochle player I ever met."

The morning after Dad's funeral, another service, organized by the Men's Club of the local synagogue, was held at Mom's apartment. She was afraid that there wouldn't be a *minyan*, the ten men required to sanction formal prayer, but

before 9 A.M., at least twenty men crowded into the living room. They wore *yarmulkes* (skullcaps) and held thick, black covered books in their hands; although I had met many of my parents' friends, barely one of these men was familiar to me. They stood for the entire twenty minute service while Susie and I sat flanking Mom, diminutive and weak, on the beige and white couch with the innumerable small pillows she was always arranging. When it was time for all of us to rise for the *Sh'ma*, the prayer at the heart of Jewish service, two men came over and helped us lift Mom to her feet. As if they were a crew of kindly uncles, I felt warmed, the room sanctified by the vintage sounds of their ancient prayers. Then, as mysteriously as they arrived, they shook our hands, murmured words of consolation, and disappeared.

Susie and I sat at my mother's dining room table a few hours later, as did Bill, my second husband and great support: midwestern, loving, steady. A few feet from us, the counter of the "pass through" between the kitchen and dinette was filled with newly washed platters that had held the bagels, smoked fish, cut vegetables, and cakes served at the gathering after the funeral of the day before. One of Mom's friends, Frieda, has joined us. We'd called and asked her to please help us with this meeting just prior to our return home.

Mom sits in her usual seat at the cherry table covered with a gold, cotton cloth. All this activity has exhausted her. She yawns and shrinks into the high back chair.

"Mom," Susie says," we need to have a talk."

Mom opens her eyes wide, as if in mock surprise. Her hands are in her lap. "Oh?" she asks.

"Yes," I say, looking at her directly.

Susie then nods to Bill. "Ruth, we know this is a hard time for you, there is so much going on, and we.... well, the bottom line is that we all really feel that we want you to have some regular help around the house now." He waves in the direction of the living room.

"Yes," Susie says. Mom has shut her eyes. The light from the decorative metal chandelier, shaped like a wreath of leaves, imprints an oval shadow on her right cheek.

Frieda says, "Ruthie, it really would be good to have some help, so many people down here do.... It's too much for you alone." She reaches over and rests a hand on Ruth's shoulder.

After a long pause, Mom opens her eyes, shakes her head from side to side and says, "I don't need any help."

A half hour of cajoling, pleading, joking, and explaining ensues as we wear her down until she reluctantly agrees to "just a little help." For shopping, doctor's appointments, some light housecleaning.

I returned home, surprised at my lack of grief. I thought: *my father died.* But I felt little. I told myself it was because we were never very close. Then, several weeks later, I dreamed he came back. There he was, glasses, his bald head with the longer strands from one side of it plastered with hair spray over the top. He hugged me in the dream as he never did in life and I *felt deeply,* I know no other way to say it, the love that had remained, for the most part, unexpressed when he lived. Of course, it had been manifest in other forms, for how else could I account for the long years of work, his return every night to us, how I could count on him?

I awoke in tears, and grieved for weeks. Ever since, I have never doubted my father's love. And I learned, for the first time, that death is not a final ending, that the dead live on, and that death sometimes can be a healing.

We hire Judith to help Mom three afternoons per week. She has recently arrived in Florida from Panama, where she worked as a lawyer; she is new at home care, has good references, and we quickly come to trust her not only with Mom, but with her checkbook as well. "How is she doing?" I call and ask every Friday, and Judith patiently explains everything in great detail. "I don't know what we'd do without you," I say.

"It's my pleasure, your mother is a great woman," she replies.

Three months pass without incident; Susie and I fly down to visit. One morning, we leave Mom alone in the apartment for an hour and meet Judith beside one of the poolside tables.

She is wearing heels and a nice dress; we're in our shorts and t-shirts.

"She doesn't really trust me anymore. She spends hours every day going through her papers, she's so confused. She's not eating very well, she won't throw out old food," Judith says.

We all agree that it's not quite time to move her, but it's getting close. We want to maintain what is beginning to feel like a gift to her now, the ability to live relatively independently in the apartment, which for years she has said she loves. With the brass plaque of "the Wailing Wall" tacked up in her dining room, with the fancy *étagere* and its glass bowls of shells, photos of the family, the Norman Rockwell plates on wall spaces between the shelves. Things she has lived with for so long that I can hardly imagine her separate from them.

Mom's turn to visit us up north, and so Judith helps her pack a suitcase and drives her to the airport in West Palm Beach. A young man sits beside her on the plane. I know this because I meet him after he wheels her up the ramp as they disembark. I'm astonished. Whenever I've even mentioned the word, "wheelchair," my mother has given me a look, a bad one. The man is about twenty, and wears a shabby plaid flannel shirt and jeans. He has a southern accent and long sand colored hair. He says my Mom is his friend now, that they had a blast on the plane. "What a lady," he says. This makes me nervous.

Pulling her large suitcase behind me by its strap with one hand, I wheel her toward the door of the airport with the other. In order to get to the car, I have to help her out of the wheelchair. It's a hard job; her stiffness seems to solidify her weight. She's wearing navy blue pants and I notice that the seat is wet. I stare at the large dark circle and know again that everything is different. I help her step out of the wheelchair, and then out of the airport toward the parking lot. Still dragging her suitcase with one hand, her arm around my other arm, we move in slow motion to my car. Patience, I tell myself. It's difficult getting her into the car. She just stands there.

She tries, but it's as if her body has forgotten its native language.

At last I settle behind the wheel with her belted into the passenger seat.

"So, Mom, how are you doing?" I ask, "How was the trip?"

A pause. "Look at the sky," she answers. We are on the interstate, and it's a clear, fine July day. The sky is, indeed, a blue to die for and it's hosting some drastically white clouds.

"Look," she says, "there's a mother, a father and a baby." She points up past the windshield, her finger crooked from the time she broke it in the subway when someone shoved her trying to grab her purse and she fell, clutching it to her chest. "Do you see it?"

I try, I really do. But I see nothing up there but the end of time.

"A mother and a father and a baby," she repeats.

At home I help change her underwear. It's the first time I do this, and it's a lot harder and less pleasant than changing a baby's. First I get her to stand up and face the wall of the guest room so she can steady herself. "Mom, " I say, "you have to move your legs a little farther apart." She stares ahead, her arms trembling slightly, her fingertips on the wall. "I'm sorry," I continue, "it will only take a minute, okay?" I crouch at her feet, pull the wet panties down and help her to carefully lift one foot, then the other. "Do you mind if I get a washcloth and some powder?" I ask, "You just wait here, hold on." She nods. I rush back and wash her down, "Is it too cold?" I ask.

"No."

I gingerly powder her soft, loose skin. The hard part is getting her feet back into the opening for legs of her underpants. I coach and help her lift one at a time in, then I slowly shimmy the cotton briefs up, careful not to topple her. Next her pants. I have no idea what she's thinking. "Well, we did it!" I chirp, leading her to a chair. I wash the panties out and hang them on the shower rod to dry for another round.

It will soon became clear that Mom's "accident" on the plane was no accident at all. She's completely lost bladder control. I buy her *Depends*. She's bemused, but not contentious. I

borrow a chair with a potty in the seat. A neighbor told me that the local funeral home lends such things at no cost; good P.R. I place it beside her bed. I steer her away from our brand new couch. I act normal, but I'm completely unhinged. She wets the bed overnight. I buy rubber sheets. I wash and wash. Overwhelmed, impatient, confused, I go to the bathroom, lock the door and cry.

Each morning I check how her breakfast is going. It takes her at least an hour to eat a meal because she must eat everything on her plate. Then she picks intently at whatever little crumbs have fallen onto her lap or chair. She works at this until she retrieves each tiny morsel and places it on her napkin.

One morning, when I go into her room in order to check up on things and water the begonia, I notice a faint orange light under the sheet on her bed. I lift it to discover that Mom's using a heating pad in order to dry the urine soaked bottom sheet. I turn it off, close the door to the room to keep her out, open the windows wide, and gulp as much air as I can. I need to get closer to those trees out there, those old maples rooted in one spot year after year making leaves and dropping them. How will two weeks ever pass? What will happen after they do?

"Mom," I explain, "it's dangerous to leave a heating pad on like that, it could start a fire."

"Oh?" she says.

"Maybe she should live with us," Bill suggests late at night. We're in bed, the almost full moon slips light under the shade I've pulled half way down. I think of diapers and wet sheets and meals, how these would become my life. "I'd die," I say. I hate how quickly I know this.

"She never had her mother move in with her," I add, "she sent her to a nursing home." I will think and say this sentence repeatedly, both aloud and in my head over the next three years because I want to be someone else, someone whose incontinent, confused mother *can* live with her, someone patient, who can give back directly the love and care she received from her mother. Like the woman I met who runs a local Hospice program and took in her dying mother-in-law. I believe

there is something ancient and holy in being able to do this, and I know in every cell of my body that I would fail within a week.

It becomes clear that Mom can't be left alone in our house, and so I hire a woman to spend a few hours with her each day. (What of people who can't afford this?) I explain to Mom that Ursula is a friend who is visiting. Mom never guesses that I pay her, Mom never questions who she is. Ursula slowly walks Mom up and down the driveway. She's German, with a very thick accent. She explains to Mom that she's not one of those bad kind of Germans. Mom pats her hand. Together they look at old family photos, sometimes Ursula asks her questions about her life. Sometimes she can answer.

We muddle through. Mom pretends to read a book of *Great American Short Stories,* which is always open to the first page of "Where is the Voice Coming From?" by Eudora Welty. She falls down in the bedroom, but when we help her up, she insists she's fine. I tell her how worried I am about her being in Florida alone; she insists she can manage. We send her home, and I hold my breath, even though we've made even more extensive arrangements for her down there. Other caretakers are put on a schedule to augment Judith's time. Money management becomes more of an issue when Judith discovers that Mom has been writing checks indiscriminately, even to right wing organizations whose policies she's always opposed. She has sent ten dollar checks both to Family Planning and to Right to Life organizations. Publisher's Clearing House has ripped her off. She has purchased the same magazine subscription twice.

Judith calls to talk about the rotting lettuce, melons, old chicken parts. "Sneak them out to the dumpster when she's napping," I suggest, "don't worry if she gets angry."

"Poor thing, she's beginning to have no idea what she's doing," Judith says.

My sister and I begin to scout nursing homes in Massachusetts; better for her to be here than in New York City, where

Susie lives. But even the nicest "homes" seem unthinkable. Our mother in a dining room with strangers? Breathing chemical smells? Sharing a room with a stranger?

Then I find an ad in a local newspaper, which leads Bill and me to Peggy with her warm aura of indefatigable efficiency.

"If we get along," she says after an initial interview, " I'll take her."

"You'll get along," I say.

After a while, Mom thinks it's her apartment, that she owns it. The flowers in the garden are also hers, as are the mountains, fields, the cows grazing beyond the split rail fence outside the living room window.

"You're a country girl now," I tell her.

With her advancing Parkinson's, it's harder and harder for her to move, and Peggy teaches her to use a walker: *lift, place, right foot left; lift, place, right foot, left.* She also assists her with showering and dressing, with meds, meals, and the perennial task of finding her wedding ring. I don't know how Mom understands this living situation. She speaks of Peggy as her good friend, and never asks if or how she and the apartment is paid for.

Peggy prepares meals for her and Jonathan, her ninety-six-year-old neighbor in the adjacent apartment. She takes them for rides; since Jonathan is almost stone deaf, the complications of conversation between an old Yankee farmer and a Jewish woman from New York City are avoided. Sometimes Peggy eats with Mom, often Ruth eats alone, chewing endlessly at the small Formica table we've brought up from Florida. It's situated beside a large picture window looking out onto the yard that Peggy's house faces as well.

It's odd to see my grandmother's glass cabinet filled with the familiar antique pitchers in this setting, to see Dad's reclining armchair, and the oil painting of the Asian woman putting up her hair, a figure I gazed on often with odd longing when I was a kid and it hung above the green couch.

Mom is in the armchair holding a newspaper in her lap. She facing the TV: picture on, sound off.

She looks up at me without saying hello. "Rabbi Henry David Thoreau," she reads aloud in my direction from the newspaper.

"Hi... Thoreau wasn't Jewish," I tell her, bending down to kiss her cheek. She kisses me back and says, "Oh yes he is, it's in this newspaper." I look down at a two week old *New York Times,* try to read it, and shrug.

"How are you, Mom?" I ask, sitting on Peggy's couch; Mom's was too big for this room.

"Not bad," she says. There are a few stacks of notes with rubber bands around them on the small end table beside her. She's in a pants suit, white and navy, which I remember well from Florida.

"It's hot in here," I say, pulling off my sweater.

There's not much else to say, Mom returns to her newspaper. On the TV an anchorwoman, with red lipstick and a black suit, mouths words about a new catastrophe. "Do you mind if I turn off the TV?" I ask Mom. "That's fine," she says.

We sit in silence. I hear the ticking of the antique clock on the wall beside the TV; it's two hours off.

Peggy comes in and sits beside me.

"Ruthie and I had Chinese food for lunch yesterday, didn't we Ruth?"

Mom nods, "It was delicious," she says. Does she remember?

"And we watched *The Music Man* at night."

Mom nods again.

"The place looks great," I say.

"The bedroom is too small, it's not good," Mom says, "I think I might have to find another apartment."

"Does it really matter?" I ask.

She shrugs.

"I think it's fine, and the quilt is beautiful, the one Peggy made."

Mom smiles.

"Need anything, Ruthie?" Peggy asks, walking over towards her.

Mom beams up at her, "I'm fine, sweetheart," she says.

Peggy leans over and kisses Mom on the lips. She does this each time she greets or leaves her. Then she smiles at me and winks.

I ask Mom if she'd like to sit on the screened-in porch for a little while. It's a late fall day, "if you wear your coat, it will be warm enough," I say. I position the walker in front of her, brace it, and slowly she rises to her feet. I go get the coat. "C'mon towards the door, then I'll help you on with it."

She begins the journey to the door, but stops after two steps to bend down and retrieve a tiny piece of lint from the beige rug; I can't believe she's able to see it.

"Mom, please don't," I say, "you'll fall."

She stays bent there, her right hand on the walker, the fingers of her left hand clawing at the carpet. "Mom, I'll get it." I pick up the little piece of *shmutz* as she watches me like a hawk; "Good," she says. She takes three more steps and there she goes, over again for another wisp. I walk right up to her, "Mom, I promise I'll vacuum after I get you set on the porch. Please stand up."

"Okay, good," she says.

Slowly, slowly she's in her jacket and out the door. A bluejay shouts past us. Some tobacco colored leaves are still threaded to an oak. I help her into an old rocker, and she sits and stares ahead, the cool wind on her face.

"I'll be right back," I tell her, then I go back into the house, get out the upright vacuum and turn it on. It roars.

9

We sell the condo, and so can't put it off any longer. Susie and I fly down to Florida to clean it out. The

place is jammed. We schedule a week for the job, hoping it will do.

It's odd to arrive at the airport without Mom and Dad vigorously waving hello at the gate. Odd to enter the apartment without them, and then to begin packing up the home of someone still living. Everything is still in its place; it reminds me of pictures I've seen of the abandoned apartments of German Jews.

"Oh, my God," Susie says to me.

"Oh, my God," I say to her, looking around: we have inherited all this power over the things our parents worked so hard to acquire, things they lorded over, a lifetime of them. We sleep in their bed, open their drawers freely, touch their clothing, handkerchiefs, jewelry, lotions, the pills left in cabinets, the dishes, coats, furniture.

"How will we?" I ask Susie.

"We will," she says, and outlines three major categories for division: what we take home for our families; what gets sold; what is given away.

The walls seem to move in on us as we begin clearing things out.

"I'll never do this to my kids, " I say, "I'm going to get rid of lots, lots beforehand."

"I can't believe it," Susie yells from the dining room. I'm in the bedroom grabbing armloads of dresses on hangers from the pole in the walk-in closet.

"Another set of glasses! Mom has enough glasses and silverware, trays and bowls to serve a sit down dinner to the entire population of Nepal!"

"Susie!" I scream an hour or so later, "Fifty-seven pairs of shoes; I just counted."

After a used furniture business sends over a truck and we empty much of the living room, we sit down on the floor beside each other. Our voices echo. Susie begins crying, I put my arm around her shoulder. "So much is over," I say.

"It is," she says, "but it isn't—" she nods toward the crowded bedroom.

"Genie!" she calls, the next day. I rush into the bedroom from the kitchen. "What's wrong?" She's holding Dad's wrist-watch, glasses and onyx ring . "Daddy's things," she explains. "They were sitting in his drawer just the way he left them."

"Oh honey," I say, and we hold each other.

A few hours later, we're taking a break, sitting in the tiny kitchen over cups of tea. "I almost hate them for this," I say. She nods.

"What would I do without you?" she asks.

"And I without you?"

Next day we sit in the screened-in porch in the back of the apartment. There is a spread of grass punctuated by a few trees. Beyond it is the white six foot tall wall that borders the complex.

"See that tree, the evergreen with the long boughs?" I ask, pointing to it, "that's the Norfolk Island Pine we gave Mom when they first moved here, the hot weather and rain must be perfect for it." It is about forty feet tall now, a rich and lustrous green, its fronds gracefully bending earthward.

Before we leave, I make a partial inventory; and
I imagine my mother's explanations:

1. No hats
My hair is thick and I like the widow's peak; besides, hats ruin your hairdo.

2. A white and beige shawl I crocheted for her, zippered in a plastic bag
I'm ashamed to say I never wore it, it was a little too "folksy" for down here, but I love the fact that Genie made it for me, and with my Florida color scheme..

3. Dozens of matchbooks from weddings she attended; names of brides and grooms in gold embossed letters on the covers: Diane and Gary, Carol and Steve
Weddings are important events, lifetime commitments—remember...

4. Outfits for square dancing: two very short fringed skirts, three vests, one pair of cowboy boots
I wanna be a cowgirl, not only a Jewish lady—it's fun...

5. A huge silver serving set—tray, coffee pot, creamer, sugar bowl; gift from the Brooklyn crowd for their fortieth anniversary
Silver is beautiful, but you do have to polish it...

6. Playbills from Broadway shows, mostly of the forties, fifties and sixties
You know how I loved the old musicals.. you know your father and I went to Oklahoma when I was pregnant with you!

7. Photos of our family—Dad's, Mom's, our immediate family of four—in black frames from Woolworth's
Of course...

8. Five sets of silver and flatware. One from her mother, sterling silver in a red velvet lined wooden box
You never know when you'll need another setting...

9. Two blenders
They were on sale, I couldn't resist; you girls can have them someday...

10. Three juicers: two glass manual ones, one electric
I like the old ones better, but for the oranges here in Florida, we had to go electric..

11. Five raincoats
Well, it does rain a lot down here...

12. Jewelry, boxes full of it. Mostly costume, some real. Elaborate, lots of stones set in rings and pins,

an old cameo, a beautiful antique watch
I like jewelry, I do, and compared to some of my friends, I really don't have much...

13. Stacks of cotton napkins and tablecloths
For company, of course...

14. Dozens of serving bowls, many cut glass
For company, of course...

15. Statuary: Sisyphus in metal pushing a gold lamé rock up a gold lamé hill; a mother with a Modigliani neck holding a young child on her lap, the two of them gazing at each other lovingly.
Aren't they beautiful?

16. The Norman Rockwell plates: a girl in the dentist's chair leaning back, mouth open; a boy sipping a milkshake at a drug store counter anywhere U.S.A.
I think they're super terrific...

17. A photo of Dad with lipstick, eyebrow pencil and a stocking over his head for his role in *The Pirates of Penzance*
Your father was an excellent actor, a real talent...

Day six of packing. Susie and I are exhausted and all too aware of the growing space around us. She notices a woman cleaning the sidewalk outside the window and goes to speaks to her. The woman is Haitian, and Susie, a bi-lingual teacher, speaks Haitian Creole.

"Can you use shoes?" she asks her.

The woman nods vigorously and explains there is a mission in nearby Fort Lauderdale that sends clothing and shoes weekly to the needy in Haiti. We resume packing the rest of Mom's stuff with far more enthusiasm. Later I keep imagining my mother's red heeled sandals or her white high heels on the dark feet of women strutting down the streets of Port au Prince.

Six months later, I receive a call at two in the morning from the state police; my mother has just phoned them from Peggy's to say that she's at a concert and needs a ride home. When asked about family, she'd given them my phone number. They report this isn't her first confused phone call to them. A few weeks later, Mom takes a fall in the bathroom. Peggy is on vacation with her family and her substitute, Donna, calls and asks me to please hurry over; Ruth has been lying, she explains, "in a mess" on the bathroom floor for about three hours; she's so sorry. I drive there immediately. Mom is cleaned up, and sitting in her chair. Her face is pale. Donna greets me at the door, and I assure her, "these things happen." Exactly what Mom would have said.

We call the local volunteer ambulance and get Mom to the hospital to be certain nothing has broken during the fall. I watch three men in uniform jackets with EMT emblems on the arm lift her onto a gurney. "Are you okay?" I keep asking. She is smiling, she likes all this male attention, she isn't anxious at all. As she is strapped to the stretcher, I explain that since I'm not allowed in the ambulance, I'll follow in my car and meet her at the hospital. "Terrific," she says.

She's unharmed, but a CAT scan is ordered, and a week later Peggy will tell me about the cap of darkness, the dead cells, clearly visible around her brain. She will give me the picture in a large manila envelope to take home, but I won't be able to get myself to look at it. I'd felt similar aversion a few years before when I'd seen my mother's aged body naked for the first time:

> Like the locked door to a parent's bedroom,
> or how in Hebrew you can never write
>
> God's name. Mystery dresses in itself,
> layer upon layer, with only

> more of itself tucked under, so that
> when I saw my mother's body
>
> her back bent, the long flesh
> falling, all I could do
> was look away.

A few months later, Peggy calls: "Ruth just can't remember to use the intercom. I can't be responsible for her day and night" she says. "It's too exhausting and I'm afraid for her safety."

Mom is placed on a waiting list for the Buckley Nursing Home in the nearby town of Greenfield. The anxiety about the timing, rooted in Ruth's growing need for twenty-four hour care, is augmented by financial constraints. My parents' savings are just about all spent on Mom's care for the past year and a half. (My father, ahead of his time with his distrust of lawyers, never consulted one regarding setting up a trust for their modest assets.)

The Buckley is a well kept, smoothly run institution with nicely furnished common rooms, sunny bedrooms for two. Fortunately, a bed quickly becomes available. After more than a year of her companionship, Peggy is sad to lose Ruth, and although she promises to visit when I tell her Ruth is calling everyone at the Buckley "Peggy," their relationship virtually ends when Mom leaves. Peggy had told me how attached she gets to her patients, how their deaths or moves to other facilities depress her, how she loses sleep. Plus, she has her own family, two teenage sons, an old, demanding house, and Jonathan, her other patient, still to care for.

Although this move is, in some ways, easier than the initial one from Florida, every step away from "normal" is complex and difficult. This step is a killer.

When she first arrives, Mom is pretty upbeat. She's also pretty demented. We're never sure if it's the medications that exacerbate the dementia, or if it's a form of Alzheimer's, akin to the "senility" her father suffered. The doctors vary in their

explanations. After her death, when I try to get clear on this issue, one of the doctors reads a psychologist's evaluation to me from Mom's chart:

> Patient suffers from dementia, multi-factorial with Parkinsonian and Alzheimer's components. Patient hides dementia well because of her social graces and apt collection of stocked, stereotyped phrases.

Because at first I'm not sure Ruth knows where she is, I never say "nursing home" to her, although in time, I will. She is taken to physical therapy often and I am delighted because after months of immobility, she is walking up and down the hallway daily, holding onto a rail with one hand and steadied on the other side by a nurse's aide. I am delighted when, on one visit, I wheel her past a woman and my mother says loud and clear, "Hello there." The woman, staring, says nothing. Mom stares back, shakes her head and says loudly, "Don't just sit there, answer, say something, this is your life!"

Too quickly, however, she seems to fall into the same deep well occupied by many of the other patients. Without consistent "Peggy-love"—the same face over and over bringing her up for air— she retreats rapidly. Physical therapy is not consistently offered. Mom's right hand begins to curl up from arthritis. Within a few months, she is far more remote, crippled, and confused.

No matter how good the nurses, the administration, the sun in her room, her series of interesting room-mates, no matter how hard anyone tries or doesn't, it is always with dread that I enter "the home." No matter how much I love my mother and value the life remaining in her, I have to repeatedly question whether it is right for the U.S. government, via Medicaid, to pay close to one thousand dollars per month to keep her alive. (At the time of this writing Medicaid kicks in when the primary family's savings are spent down to one thousand dollars.) For the two and a half years she lives at the Buckley there is also the persistent question of whether or not she should be living in my home, if I should be doing this

whole thing differently. And always I end up with Ruth at the Buckley. And my visits with her.

Mom is wheeled toward me where I sit in the lobby. I watch her getting larger, pushed by a woman with brown hair whose name I do not know. Mom looks crumpled. Someone's put a strand of wooden beads around her neck. That's nice. It isn't until I stand and walk right up to her that she sees me.

"Oh!" she says, astonished, "it's my daughter."

"My daughter, my baby," she repeats. Her eyes fill up with tears. "Can I kiss you?" she asks.

"Of course," I say and bend down. She kisses me very hard on the cheek. I kiss her back, and then look at her closely.

"Can I kiss you some more?" she asks.

"Of course, " I say again and bend down beside her once again. I don't mind, although it feels like she's trying to suck the life out of me. Then I start to cry. This happens to me a lot here.

"We'll go somewhere private," I say, and wheel her into an empty conference room. Brightly lit, there are lots of windows and I see snow piled up outside. I situate Mom at one end of a huge, mahogany conference table. It gleams. A vast, shiny chandelier hangs above us. This is our sky. Ruth never wants to go outside anymore, and it's too cold. We sit face to face. Someone could chase us out of here any minute, but for now we've found a place to be alone.

We look at each other and she begins crying too.

"Well," I say, "we might as well just cry since that's what we're doing."

I reach down and pick up her good hand, it's cold. The other one is completely fisted now. I look down at her lap, her faded navy blue slacks, the ones she wore on her summer visit to my home.

"Mom," I ask, "why are you crying?"

She thinks for a few moments. "I don't know my ass from my elbow," she says.

"But it's okay," I counter, "You are old and you are sick. You don't need to know anything, not really. You gave so much

to your community, to so many people in your life, you were a great mother—now it's time for other people to take care of you."

She looks around and thinks. "But," she says, "see over there...." She's staring outside the window at the far end of the table. "Stuff, those things...."

"Do you mean you remember going out in the car and doing errands, getting things done? Do you feel you should be doing them now?" I'm trying to find a brain wave I can ride on with her, I want to surf to a good shore with my mother. She was such a goddamn strong swimmer. I remember her arms, how they'd slice the ocean or the aqua water at the pool we went to when I was a kid.

"Stuff," she says, "...stuff."

She's fallen off, I can tell, she's lost it.

"Mom," I say, "what's the matter?"

She looks sad and confused. Her thick hair sticks up at an odd angle on the left side of her head. The few mustache hairs she used to pluck are long and dark. I must remember to bring the tweezers next time. She is so pale. Her skin so smooth and beautiful.

"I'm Ruth Zeiger, right?" she asks.

"Yes," I say.

"I'm Ruth Zeiger, but I'm not Ruth Zeiger," she replies, staring ahead.

"Mom, " I put my face right in front of hers. "Do you want to die?"

"Oh, no," she says immediately, "Oh, no."

"Maybe," I press on, I don't know why, "maybe you'll see Daddy and your Mama and Papa when you do."

She smiles, a wry, unconvinced smile.

"It would be fun, you could have a party."

Silence.

I'm still upset, but she's not. Why am I saying such dumb things to her? She can't remember long enough to sustain a feeling.

"Mom, I have to go now." I don't know what else to do, and sitting in this conference room has begun to feel like be-

ing at a terrible conference. "I have things to do, "I say, "stuff—I need to meet a friend, go to the bank, Xerox some papers...." Stuff, the stuff she can no longer do and, without the doing, feels ashamed.

I bring her back to her room in a rush because I want to do all my goddamn errands, and I want to enjoy the doing of them, to get them the hell accomplished. And I want to get out of there and I'm out, on the road, tears running again as I open the window and gulp in big breaths, inhale as far down as I can, breathe and breathe. I go as fast I can, down Laurel Street, left onto Route 2, as fast as possible without seriously risking getting killed.

<p style="text-align:center">≈11≈</p>

A week later I bring Mom her newly repaired eye glasses. She looks up at me, pale, crumpled and dully glowing. "I love you," she says. We are in the pseudo-elegant dining room—round tables with pink cloths, a brass chandelier hanging from the ceiling, upholstered mahogany chairs with arm rests. A woman in a bright blue sweater with matching eyes sits across from my mother. "I love you," Mom repeats staring up at me. Her dining companion quips, "Oh, she loves everyone."

"Well," I counter, "isn't that what we're supposed to do, love each other?"

The woman doesn't answer, but lifts a white cup of coffee to her lips and stares ahead.

I sit at the table for a while. "Bye, Mom," I say, being sure she has the glasses safely tucked in her pocket,

"I'll see you later today," she replies.

I nod although I probably won't see her for a week. She won't remember anyway. She recently told me that my father

was visiting her soon. "Mom," I said, "he's been dead for three years now." "Oh," she said with a small smile.

The next week, she begins making popping sounds with her mouth, like reverse kisses. She seems to deeply enjoy the noises. She moves her mouth very intently, as if she were talking to someone deaf. Her eyes are wide open and the sounds are loud. She's good at this, I think; this is something she can now do well. It's something, I tell myself.

It is difficult to know what to do in response. I want to communicate with her, be with her, and so I try popping back once or twice, but I feel ridiculous. I think how she is a fool, Lear-like; do I have to make popping sounds and be one too? I stop. She keeps going. It's odd to watch the stern mother who commanded obedience in "the land of please and thank you" sitting in front of me popping. She looks like a washed out cloth, pale and crinkled. There is a stain, the color of mustard, on her right shoulder. She's only eating soft foods now because of her new habit of "pocketing," which the nurse explains means stuffing half chewed food in her cheek rather than swallowing it. "Why doesn't she just swallow?" I inquire. Chris, the charge nurse, explains that very demented people forget to swallow. Plus her throat muscles are rigid from the Parkinson's.

I visit the next day at feeding time to make sure she's getting proper nourishment, and learn that Mom has a new diet—liquefied vegetables, soups, custards. I see she isn't interested in eating as I carefully raise a spoon of cool tomato soup toward her mouth. She concentrates, takes it in, then swishes it around inside her mouth as if it were Listerine. Side to side, her cheeks bulge, her lips pucker as if ready for a kiss. "Swallow, Mom," I coach, "you have to swallow." She concentrates and then, slowly with visible effort, gets it down. It's hard work. I decide that the yellow funky circle on her shoulder must be some sort of dried custard.

"Hey Mom, let's sing." I suggest after she finishes her meal. "Do you want to sing?"

She looks up and nods vigorously.

"What do you want to sing?"

She sits and stares.

I know her repertoire. The last of the memory lines to go are the ones that hold songs.

"Why don't we sing, 'Show Me the Way to Go Home?'"

She recently sang this as a duet with her physical therapist, Aggie, in the nursing home talent show. That old, achingly simple melody rippled through the activities room. Could there be a more ironic, tender expression of how lost she now feels? Afterwards, Aggie told me, almost everyone was weeping.

Mom looks wiped out. I wonder how she sleeps at night, I wonder what she dreams, I wonder so much about this woman who was, who is my mother.

On Mom's tray table is a glass of prune juice. Since she no longer eats fibrous foods, she gets constipated. There is also a glass of cranberry juice; they seem to treat her well here; I trust they treat her well here. When Chris, the nurse comes in to say hello, I tell her, in Ruth's presence, how my mother had been president of numerous community organizations, including Girl Scouts, and Hadassah, how she had gotten her bachelor's degree at fifty-two, and her master's in education at fifty-five. "Really?" she replied.

A social worker assigned to the nursing home tells me my Mom is "dignified." Dignified with maybe ten percent of her brain activity, with ten percent mobility. Wistful and lost. Dignity with so much stripped away. A lovely lady with no idea what her parents' names are, where she is, or where she ever lived. I search for her in the ten percent. What remains after the flesh fails? Is dignity in the bones?

Mom is beautiful and full of spirit. Mom is a dumb ball of love. She kisses the hands of staff. She tells people, even the most homely, how beautiful they are. She is the oddest mixture of things. In my deepest heart I know she's all right; I know this with the part of my brain that is oldest, perhaps, the part that does not think but understands deeply, intuits. But my rational self, the part she helped cultivate is appalled, confused and grieving. I cannot reconcile this fool with the idea

of *mother.* I am afraid for my life too. I have no idea how this will all end, or when.

I return to visit her in a few days and notice that the roses I'd brought her recently are dry and dead, the red muted and tinged with brown. I pick them up.

"Don't throw them out," Mom says.

"I won't," I reply, then go into the bathroom and toss them into the garbage. I refill the vase with fresh water for the collection of purple and violet irises I've brought today, arrange them, then place the vase on top of the TV. She doesn't notice. Next I get tweezers, sit in front of her and pluck the extra hairs on her chin and lower lip. She'd agreed to this after I offered last week, and she doesn't even grimace. "Thank you," she says after each small tug of the tweezers.

"You're very welcome," I keep repeating. Then I'm done and there isn't anything to say or do.

"Do you want to watch TV?" I ask,

"Sure," she says, and on goes the tube and there is the soprano, Jesse Norman, singing Christmas carols in May. My mother stares at her for a while, then says, "She's very proud of her breasts." Jesse Norman is wearing a very low cut scarlet colored dress, which does indeed accentuate her chest, but why would Mom notice that when her face is so strikingly beautiful?

"How do you know she's proud of her breasts?" I ask.

"I just do."

I shrug and look up to see my ex-husband enter the room. He'd offered to visit; she hasn't seen him for years.

"You remember Charles," I say, knowing she does not.

She looks up at him. He is holding a small bouquet of wildflowers and lilacs. She stares up at him. "I love you," she says. He bends and kisses her, "and I love you too," he says, "we were good friends from way back."

Ruthie, having run out of thought, begins her popping sounds. Charles, across from her, perched on the end of her bed, responds in kind. Pop, Pop, Pop. He keeps smiling and popping. She keeps at it too. Momentarily I think of her as a

new baby hooked up to the love source of the cosmos, back in diapers, with soft foods, with songs, with popping sounds, with eager-eyed love. How astonishing it is to consider— so many acolytes trying to find God, believing, *love is the answer, all you need is love, love thine enemy* and here is my mother, her body stiff and her mind emptied of the past—she can't remember her childhood, her sister's name—but she breathes. And loves.

And here I am with so many memories still alive to me: Mom throwing a fistful of pennies at me. Mom radiant in her mink stole about to go out with Dad on a Saturday night to visit their friends in Brooklyn. Mom placing her wide gold wedding band on the cut glass sugar and creamer set on a shelf by the kitchen door. Mom holding a dead parakeet on her lap on a pink, folded tissue. Mom doing the twist to Chubby Checker with me after dinner. Mom collecting money on the phone for Hadassah. Mom holding her own mother's hand as grandma, old and confused, asks, "Where's Papa?" who had died years before.

"I wish I felt as comfortable doing that popping thing with my mother as you do," I say to Charles as we leave the home.

"It was fun," he says.

"She's not your mother," I respond.

<center>~12~</center>

Mom never talked to me about sex. When I first got my period (it was on *Yom Kippur*, a day of fasting and mistaking menstrual cramps for hunger, I ate a bowl of cereal), she sat me down after I told her the news. She gave me a tiny slap on the cheek, *to get the blood back to your cheeks*, she

explained, *it's a tradition*. Then she gave me a book published by Modess entitled *What Every Girl Should Know*.

Five years later, eighteen and engaged, I became pregnant. This was partially a result of ignorance, as well as placing too much trust in my fiance's report that withdrawal was a fine method of birth control. I was living with my parents and finishing up the end of my junior year at college. I got up before anyone else each morning and threw up quietly in the bathroom located, fortunately, just outside my small bedroom. I cleaned up around the toilet and sink, then carefully cranked opened the cloudy thick window above the bathtub. Standing on my toes, I stretched up and inhaled the still dark sky. Then I crept back to my room, my hands over my belly. I had a little stash of Saltines in a plastic container under my bed. I'd sit, nibble and breathe, nibble and breathe.

Our plans were set—Charles and I had found a doctor who directed us to a clinic in Puerto Rico for an abortion. We would leave just after the wedding, for our honeymoon. Oh, it wouldn't be bad, nothing much. We'd lucked out, we'd arrive at just the right date, before my third month. The timing was perfect. Afterwards there'd be fun—swimming, hikes into rain forests.

The wedding preparations continued apace. It was really my mother's wedding; I would have been happy to visit a justice of the peace. I had no taste for the lavish menu, the two hundred people, the embarrassing hoopla in an ostentatious hall with chairs covered in midnight blue velvet. At her request, I'd had my hair set and done at Ella's, her beauty parlor, the night before the wedding. After I came home and checked myself out in the mirror, I stuck my head under the faucet to undo the stiff bouffant. My nails were manicured, covered with clear polish; even that gleam was alien.

About an hour prior to the ceremony, I stepped into my cream-colored floor-length gown with its long row of pearl buttons in the back ascending from below my waist to the base of my neck. My mother began the buttoning.

"Goodness," she said, struggling to get a pearl through the circle of fabric that was the eye hole, "You've gotten fatter," she said.

"Uh huh," I said, sucking in as much of me as I could.

All the lewd jokes my parents' friends made, and there were lots of them, about the romantic honeymoon, our alleged "first time" together were wasted, bitter.

Mom never learned about the abortion. How the procedure, thanks to a spinal, was painless. How I'd been lined up with dozens of other American women, most of them a good deal older than I, in rows on gurneys. How small I felt. How Charles and I believed it had to be done (I had to finish school, for one thing). How I began bleeding profusely as we waited on line to board the plane home, and how no one had told me that would happen. How scared I was about not being able to have kids later. How there was no one to talk to about any of this.

The following year, 1968, found my mother beginning a new life. Her daughters were gone from the house, one married and one to college. How was she to fill her days? Whom was there to talk to, and about what? She disliked gossip, and this left her on the periphery of that gluey neighborhood excitement. Taking the moral high ground is isolating. Her relationship to my father had already thinned into something workable, but uninspiring. And so she became one of the first students in an innovative program for older students called ACE (Adult Continuing Education). Participants attended classes and received college credit for them as well as for properly documenting their past life and work experiences. In her early fifties, Mom was studying education and taking the many required courses for a bachelor's degree at Queens College, the school from which I had just graduated, part of the City University of New York. College was entry into a new life, an opportunity to be engaged with men and women her own age in pursuit of a higher ideal; ideals were things she was always wedded to. College was a way back into vitality, into a life fully lived. Mom always took big bites of things. When

she picked up an apple, a good third of it was gone with that first crunch. That avid quality took her back to learning. Her father, had he been living, would have approved.

I had recently graduated from the same school, was married and gladly pregnant with my daughter, Mara. Mom was studying the Greeks when I suggested we see *Iphigenia at Aulis* performed by an experimental theater in the round in Greenwich Village.

We sat on folding chairs close up to strangers on all sides as the Trojan War raged and Iphigenia's father, the king, waited for his fleet to set sail. For weeks there had been no wind, and so an oracle was consulted; Iphigenia, a young daughter, the oracle said, must be sacrificed so the fleet can embark. Clytemnestra, Iphigenia's mother, is in a fury (later she will take revenge), but her husband, Agamemnon, proud and majestic, is adamant: Iphigenia in her flowing robe, she of the fair, long hair, must die. And the girl agrees to her fate, becomes its willing victim.

My hormones and I watched this young girl about to be axed for the sake of her father's glory and ambition. I remember Ruth beside me, the two of us holding hands as we unabashedly underwent what Aristotle had prescribed for successful tragedy—catharsis. Mom kept plying me with Kleenex from her purse, and the sodden wad grew in my hand as my baby floated inside me.

Shortly after the play, my mother refused to talk to me. For three weeks and two days. She was furious because I had informed her that I wasn't going to name the baby after her mother, my grandma Mary. Jewish tradition has it that one names the newborn after the last close relative to die, using the first letter of the deceased's name. That was how I'd ended up Gene, or Genie; My father's mother, Gussie, had died a month before my birth. My mother hadn't liked Gail or Gloria or Genevieve, and so, after her own months of fretting, my Uncle Manny came up with the idea of Gene, (he'd just seen the actress Gene Tierney in "The Razor's Edge.")

I'd wracked my brains in the ancient Talmudic tradition of brain wracking—Marian, Miriam, May, Melissa, Margaret— I consulted all the name books, and didn't like any of them. Finally I told her, and she became as righteous and outraged as her father had been when she'd told him she wanted to marry my Dad before her sister Toby had married. And I was devastated. Five months pregnant, I was vulnerable with the new life I'd just begun to feel within me as I'd sat in that last seat on a bus the week before, a small palpable drum, the pulsing of a foot or an arm against the wall of my uterus. And here was my mother angrily separating herself from me.

I cried, lost my appetite. I couldn't stand her displeasure, the terrible strain on the cord that joined us, mother to daughter, daughter to mother, and so when my sister's new roommate at college appeared for a visit and was introduced as "Mara," I went for it. It was a pretty and interesting name, although it meant "bitter" in Hebrew. I called my mother, and told her. "That's nice," she said, then went on to chat as if nothing had happened. She'd won this one, and I told myself over and over that it was okay, but it was not.

In a larger way, it had nothing to do with us, it was the old struggle between tradition and individuality. She'd taken up some ancient ax. My weapon was my youth and the *chutzpah* of the sixties, its atmosphere which I was inhaling in spite of my early marriage and pregnancy. She was angry again when I bought a *Volkswagen* because it was German. During that era, I was once walking in Central Park tucked between Charles and his best friend, Madison, an actor. My parents were with us, strolling behind. It was a great summer day, kids were flying by with red and white boxes of popcorn, the grasses and trees were in green and glory. As was I. I was wearing my new suede mini-skirt, and I felt like the Queen of Sheba, my men on either side of me, my parents in the rear. Then my mother summoned me, and I ran to her side. She looked me in the eye; "It's disgusting," she said, and I shrank. "Where's your girdle, you're jiggling, where's your bra?"

As Mom fades in the nursing home, retreating from contact, I wonder who she was before. I remember how she'd told me, when we were shopping at the time of my marriage, "never refuse your husband." Since she'd never discussed sex with me, this seemed odd, but I nodded, as if she'd suggested buying kosher meat. She told me always to be kind. Love God. Finish your meal. Polish your shoes. Make your bed. Don't gossip.

I heard her argue loudly with my father only once in my entire childhood, and my sister and I ran out the door into the hallway, whispering "divorce."

I remember her crying only once, when our parakeet, Twinkle, died. She never yelled at me. When I was thirteen, she threw my penny collection around my room in disgust after I'd said something sassy. A little later, she'd been lecturing me about something. I was sitting on my bed, a fat book in my lap as usual, and I looked her square in the face and said, "Shut up." "What did you say?" she asked. I sat still, frozen. Then she walked toward me, took me by the arm and marched me to the bathroom. I was too shocked to do anything but comply. She wet the soap, it was a fat pink bar of Lux, and forced it between my lips. I spit and sputtered. She took it out fast without saying a word, and left the pink and black tiled bathroom as I stood leaning over the sink spitting and rinsing over and over.

I never really talked to my mother. Early on I'd figured out that she didn't want to know about my fears, loves, and longings. For one, she never spoke to me of hers. I kept my mouth shut and spoke to my diary. Later I spoke to friends, lovers, therapists, and friends. I write this book.

When she was in the nursing home, when she had advanced from mild to moderate to extreme dementia, my mother returned to what may well be an original state of adoration. I could have arrived with pink hair and a pierced eyebrow, my face dirty, and scarred, and I would have been beautiful. She loved everyone, laid her ancient baby eyes on even the most homely of aides and told them of their loveliness. Sometimes I'd feel small pangs of jealousy. For a long while,

whenever I'd visit, she'd gasp, "My daughter!" and her eyes would fill with joy, the love in them oozing. Perhaps only a simple undifferentiated brain, or a destroyed one, can function in the depth of such innocent openness. Unclouded by hesitation or qualification— she could no longer think— she loved fully. Her words were the equivalent of a baby's drooly smile, bigger than the world. Like a baby, she was diapered, lifted and lowered into bed. And she'd suddenly begun to eat with her fingers.

≈ 13 ≈

"Hi, Mom," I say. We ritualistically kiss and I wheel her into the activities room with its large console TV chattering at no one. I turn it off and move her towards the window. Driving here, I'd heard an emergency broadcast system alert about rains, flooding, perhaps hail.

I try conversation; all I get is how beautiful I am.

"Oh, Mom," I reply, "you tell everyone they're beautiful."

She shrugs as we hear the first crash of thunder and the sky begins pouring down heavy rains. Lightning flashes and we watch through the windows. Then the electric lights flicker and I hear a nurse call, "Relax everyone, we have a back-up electrical system."

"Relax everyone?" I think. Most everyone here is comatose—if they relax any more they'll be unconscious, maybe dead.

The sky keeps up its drama. With each lightning bolt, I startle. Mom shakes her head, her face expressionless. Another bolt and I jump again. My reaction, in large part, has to do with another electric storm, one that I thought would kill me. Charles and I were sleeping in our bed beside enormous double-paned windows, almost a wall of them, when the

thunder began. It intensified for perhaps fifteen minutes, and then lightning hit the house, or me; I was screaming. Charles insisted later that he saw me levitate a few feet off the bed, my head thrown back; he'd thought I'd been directly hit and was dying.

Something had happened. Although I was physically well and there were no signs of bodily damage, I began having dreams. Night after night, I'd awaken quivering with the image of sheets of white light. One night, after being awakened, I sat up and reached for the lamp beside the bed. Before I quite touched it, the electric bulb lit up, fizzled and died. Charles admitted being scared of me, teased me, called me *witch*. Eventually the white light retreated, but fear, in the form of an involuntary gasp, won't quit.

Hail, the size of mothballs, begins to pelt the asphalt roof of the nursing home. It's close to eighty degrees outside, and ice is falling from the sky, pinging and bouncing off everything. I stare and, for a moment, the dilemma of my mother— how will we endure all this—passes away. The storm is so much bigger than her malfunctioning brain, than a disease known as Parkinson's, than my grief. If ice falls from the sky in August, anything is possible: miraculous healings, a serene and beautiful death.

When my daughter was about seven years old, I remember another storm, and another mother/daughter pair at a window. Mara and I were alone in the big old farmhouse we lived in on Patten Hill. The sky suddenly grew very dark, and I called her to the window where kneeling we watching the lightning over the hills flanking our house. It was scary and stunning. Her hair was curly, light brown and to her shoulders; she was at that stage when her teeth were too large for her mouth.

We were small, but together we were big because the bonds between us were as fierce as the lightning that wracked the big sky. We watched for a long time until it lightened from dark gray to a pale, blue-gray. Across the gravel road was an

old weathered gray silo with metal rings around its cylindrical body to brace it.

"Look," I said.

There was a white bird on top of the silo.

"It's a dove," I told Mara, "a dove after the storm, like Noah." She saw it too, its white sleek body bold against the sky. I added, "Maybe it's just a white pigeon, an albino, but it looks like a dove to me."

Mara said nothing. She looked with her eyes, not her mouth. That's what she does.

Twenty-five years after that storm, she and I are talking on the phone. I've just returned from visiting Ruth.

"Do you remember, I ask her, "the lightning up at the farmhouse, how you and I were there alone and watched this incredible storm for a long time?"

"No," she said, "I don't remember that."

"There was a bird, a white one, maybe a dove...remember?"

"No, I'm sorry," she said.

≈14≈

As a child, each fall when school began, Mom took me on the subway to go shopping for new skirts, sweaters, and blouses in Manhattan. After she paid for them, the clerk folded the items in tissue paper and tucked them into a brown cardboard box, which was sealed with a sticky tab and a rope handle. I held the box. It was treasure, especially when I got that gray felt skirt with French poodles printed on it. They had rhinestone eyes and pink leashes around their necks.

I liked sitting next to her on the train, liked how our bodies swayed together as the car lurched and stopped. We didn't talk much, it was too noisy. It was nice just to sit and notice how both of us obeyed the same laws of physics, of motion and rest. And so did the man with dark skin and a red cap who sat across from us, and the Chinese lady with paper bags on her lap and the mom (who really looked like a girl) with a baby asleep on her shoulder. That mom looked so tired, and her eyes kept shutting, but she held on tight to her baby. Although the wicker on the seat was itchy, the subway was like a big cradle.

How connected my mother and I were. If I had magic glasses, like the ones I wore once at the 3-D movie, I'd see a big rope extending from her belly right into my own. If I had seen that physical connection then, I would have said: "Oh, that's why I know she loves me so much, more than anyone really. That's why I suck my thumb, to feel her with me, and that's why I have to get out of the house, have to play stick ball and *catch-a-fly-is-up*. That's why I have to read about other people living all over this world. My body has to stretch that rope so I can grow up, so I can become a far away person too."

It wasn't bad, this job of separation. My body was strong enough for it, my mind eager. Off we went. Or so I thought. I left home for college and adjusted well. I got married at eighteen. I moved away. The rope was, I thought, like the umbilicus, severed. Now it was only me—my interests, my dreams, my accomplishments, my loves, my own kids.

Then, when my Mom began dying, the rope began to creak and groan. It was twisted now, and complex with time, solar and lunar rhythms, with memory. As she was dying, it clenched tight; and my digestive system stopped working. My gut wouldn't settle down. My stomach hurt, my intestines roiled. At its worst, I wouldn't sleep for the turmoil in my middle.

The therapist I consulted asked, "What are you having trouble digesting?"

It was all too obvious.

Mornings were the hardest, being pulled from darkness into days that were long, bright and relentless. Another and another and another. I would drag myself outside as soon as I got out of bed, pull the closed day lily of yesterday from its stem, see what the vegetables were up to, the flowers. I'd also feel that, in spite of grief and fear (or because of them), the earth was trying to keep me alive, offering me flower after flower (what the poet Rilke called "an infinite muscle of reception")— sedum, iris, marigold, foxglove, lupine. After all, I'd done so little, simply put a seed or plant into the ground, a bit of compost, some water. I thought, *nature does not care, but it consoles*. The solace of earth made me want to tend it. And earth cradled the part of me that felt it was dying with my mother, earth helped nurse me back to health. I'd go out at the edge of our woods, lie down in a heap on the ground and mourn. I set up a spot for this just beside an outcropping of ledge. Each time I went there to cry, I'd place another stone on top of the ledge before I returned home.

As time went on, and my grieving with it, the symptoms slowly began to abate. I felt better, but wanted to feel "fine." The body, after all, is innocent, it wants only to be happy. I consulted an acupuncturist, recommended by a friend. His office was his house, an old down-trodden one with lovely overgrown gardens dotted with statuary, the inside littered with Renaissance prints—young women with elaborate hairdo's, scenes of hunts, and unicorns. The house smelled of Chinese herbs, odd looking dried skins of fruits and skinny brown twigs, which he'd buy fresh weekly in Boston, then custom mix in a Cuisinart for his patients. Old Celtic music played, vocal and ethereal.

"This will help you," Tom said, handing me a plastic ziploc bag full of a pale tan powder. I noticed threads, lumps, tiny pebble-like things. He assured me that the combination of needles and herbs would do the trick. Tom was an idiosyncratic health care provider in that he'd sit with patients, whom he saw only one at a time, for the entire hour in which they were "needled." Visiting his office was like entering an earlier, slower century, and I liked it.

After a few months of treatment, I returned one day and lay down on the table. I explained that although there was still some irritation in my gut, it no longer felt like a crisis: my appetite was improved, I slept better and had more energy. He checked my pulses. "How are they?" I asked.

"Stronger, but still wiry," he said.

He put needles in my feet, legs, wrists, and belly.

"I'll be right back," he said, "I just have to mix up some more herbs for you, okay?" As he was leaving, I began to sob. He stopped and looked down on me.

"Do you want me to stay?" he asked.

"No," I answered, "I'm fine." I'd had a few crying reactions to treatments before, and so I lay there trying not to let my sobs jiggle the needles. Tears slid into my ears, mucous dripped down the back of my throat. I felt as if someone or something was actually lifting my mother from my body, from my lower abdomen, the place in which I would have carried her, had she been my baby. I felt metal, as if forceps were used, and the sorrow of her departure. And I felt relief as I breathed and felt the empty space that was left.

"Are you okay?" Tom asked when he returned about ten minutes later.

"Yes, I'm okay."

I went home, shaken and exhausted. Bill was leaving that night for a trip he'd planned months ago.

"Do you want me to stay?" he asked.

"No," I said, "it's okay."

"Are you sure?"

"I am."

That night, alone in the house, I developed a fever for the first time in many years. Vaguely frightened, I thought how odd it was that Bill left on the very day I'd felt my mother leave; how odd that I'd instantly become the kind of sick one feels as a kid.

Then, alone in our house I began hearing my mother's voice. For example, I'm lying in bed, sweaty and thirsty.

"Put your robe on and slippers on," she says, "keep warm and get some more fluids into your body. C'mon, up you go,

you need to drink. That's it, good girl." I wasn't hallucinating—my fever was only 101.

Then, hours later—"Get out of bed again and walk around a little, see how you feel. Good. Now call your friend Ellen and ask her to buy you some bananas and bread for toasting; you need to eat, and you're low on bread."

She was back in a form I recognized, that voice, those admonitions, that caring. I wasn't scared, but it was, well, *weird.* She stayed with me through the four days of my illness—instructing, commanding, tending me. Had Bill been home, I thought, he would have done this.

A week later, I spoke to the bereavement counselor at Hospice who'd offered help if I needed it. We met in a windowless room with a bookcase filled with books like *Who Dies? How We Die, Healing Into Life and Death*. Jean is a calm and wise woman. I talked about the last two years, of my grief, my illness. Then I took a deep breath and told her about hearing my Mom's voice when I was sick. "It's not the kind of thing I'd bring up in casual conversation," I said.

"Oh," she said, "I hear that kind of thing all the time. Your mother must somehow be in the two worlds now—this one, and the other."

"Oh."

When I spoke of the continuing pain of watching her die, Jean offered advice: "Try to see her as she is now, demented and crippled, as simply assuming another one of her disguises. We're all constantly changing how we look, act, our facades. The true self is under there, and apparently elsewhere as well, since she has come back to you to help you as she would have when she was younger."

What is the boundary between the living and the dead? I told Jean that I felt closer to my Dad since his death—that I saw him, heard him, knew him in intimate and more vivid ways than I had for most of our "real life" together in a family. I told her about the dream I had in which he came back and held me in a manner that expressed all the love he had no idea how to show me when he was alive.

"I guess he learned something where he went," she said.

As my mother dies, the days will be remembered for their clarity. Days tinged with a rosy duskiness, as if the sun were always setting. I often listen to Bobby McFerrin's *Medicine Music*, particularly his re-written twenty-third psalm, which he dedicates to his mother: *Glory be to our Mother and Daughter and to the Holy of Holies. As it was in the beginning, is and ever shall be, world without end. Amen.* I want to bring that world, the one without end, the one in which all things happen at once, the one in which time is nothing, I want it mixed in with the all too real one I keep having to face in the nursing home, the one with lost minds, and teeth, and lost glasses and memory and walking and how to use a spoon.

Things seem both themselves and emblem. Things around me assume a certain intimacy, as if my mother's dying has invaded them. I often feel a presence with me—is it death, or God? It seems a marriage of the two. Unlike the deity of the Old Testament I had been taught to fear as a child, this presence lacks gender and a spirit of vengeance, it is bright and inclusive of everything, it is nothing I'd ever expected to encounter, as I had not expected my mother—economical, sharp and demanding—to become the stiff demented old woman who loved everyone.

Yet even with the recognition of a benevolent spirit, entering the nursing home was always difficult, a wild card, I never knew what I'd get. Once I arrived and her door was shut. I knocked.

"You don't want to come in here," Carmen, an aide said as she opened it slightly. The smell of shit filled the hallway, and I knew it was my mother's. I fled down the hall. I couldn't stand the odor there either, that chemical perfume, thick and antiseptic, but not strong enough to mask what was happening.

There was, then, the acuteness of odor as my mother was dying, and a persistent need for fresh air. I'd stare up at the sky and feel the awe I must have felt as a little girl when I looked up at my mother's face; her black hair, that dark sky, and her eyes, my stars. During the few years before my mother's death

the stars were more companionable. The planets larger. Their vast presences mitigated her shriveling, their brightness magnified her love. "Maybe," a devout friend said to me, "your mother is already living in the other world." I knew he meant the formless world before life, and after death.

"Maybe," he said, "that is why she is so loving." I wanted to believe him.

As my mother died, I often bought myself small gifts, as she had for me. These acquisitions cheered me. I loved the small gold hoop earrings she would have admired, the black shoes, the scarves I'd wrap around my neck after she could no longer lift her arms to hug me. My favorite was soft beige, green and rose, her favorite colors.

I bought my mother things too, brightly colored shirts, pants and sweaters. I wanted her to look upbeat and cared for. I brought her movies to watch, and cookies to eat. I rubbed her shoulders, I held her one good hand. I was learning to live with death, and it instructed me, especially when I was alone. Tying a shoe, setting a table, walking on an icy road. "Careful," death said, "notice... breathe...ignore small unpleasantries, but embrace the big ones."

≈15≈

Away from home, on a trip to the southwest, I begin to understand that what requires adjustment is not my mother's condition but my understanding of it.

The northeast, where I live, is like the mind—geographically complex, and dense with vegetation and changeable weather. The southwest is its opposite, not just in terms of direction; it is the open spirit, wide sky. It is land extending in a flat forever—the gasp of a canyon, a place to dive down into, die inside of, fly up from. I see in that expanse how my

mother's deterioration is in the nature of the things. Here I plainly view the severed head of a cow intact in a canyon, faded, dry truck tires, feathers detached from a bird. And dry wind. Everything moving without restraint, with no manners. Dust in your eyes, the wind stealing your hat. At the Santa Fe Flea Market, I was peeing inside one of a row of portable toilets when the wind blew the door open revealing me squatting and staring into the eyes of a strange man in a cowboy hat who smiled at me.

The next morning I am hiking in a canyon in Abiquiu, New Mexico, near Georgia O'Keeffe's home. She called this place "the white way," and it is full of light, ghosts and walls, cliff face riddled with stones. A dead calf, brown-skinned, is lying on its side near a set of tire tracks. It is a place full of omens, and as I walk in the fierce sun, I ask for a sign to help me through my hard passage at home. I keep walking and looking, concentrating on my wish and then, a few minutes later, it arrives in the form of a battered book at my feet. I pick it up, an old copy of *Charlotte's Web*, a book I read repeatedly to my kids. It is the story of Wilbur, the pig, who is the good friend of Charlotte, the spider, who saves Wilbur from being slaughtered by Mr. Zuckerman, the farmer. This copy, like the Torah, is scrolled open—to this passage:

> "I don't want to die!" screamed Wilbur, throwing himself to the ground.
> "You shall not die," said Charlotte briskly.
> "What? Really?" cried Wilbur. "Who is going to save me?"
> "I am," said Charlotte.
> "How?" asked Wilbur.
> "That remains to be seen. But I am going to save you, and I want you to quiet down immediately. You're carrying on in a childish way. Stop your crying! I can't stand hysterics!"

Reminds me of what my mother might have said to me in my dreams, what any mother might say to a frightened child.

As I continue walking, I see my own life as if from a great distance, and know that I too will be saved. That God lives in our pain. I see how my losses, old and new, have created the person I am now, someone learning to live more closely to spirit, and to death. Death is in the passenger seat now that my kids have grown, and my parents dead, or nearly so.

"Hello," Death says. She sounds like Marlene Dietrich.

"Hi," I say, "beautiful day."

She nods and looks out the window. Sky like the dome of Notre Dame, how I felt when I first sat under it, eighteen years old.

"You're right," she says.

I touch her thigh shyly. Pink silk. She's impassive.

"Nice pants," I say.

"Thank you very much."

We drive on. She advises: "Dress nicely, it makes you feel good, and don't spend too, too much time alone now." Then she adds, "Remember to look up *and* down. Everything is everywhere, now and always."

<p style="text-align:center">❮16❯</p>

Although the nursing home is a good one—it's clean, the staff is caring, the food well prepared—I continue to struggle with the fact of my mother living here. And although I know there weren't nursing homes in ancient Greece, I imagine myself the goddess Demeter.

Demeter had only one daughter, Persephone, the maiden of the spring. When she lost her, in her terrible grief Demeter withheld her gifts from the earth until it turned into a frozen desert. As Demeter, I am outraged—not by the disappearance of my daughter, but by my mother's abduction by age and illness, and my inability to save her. What would Demeter have

done had she seen her mother, crippled and demented, sitting in a wheelchair among other old shriveled women; women mumbling strange things, or sitting mutely, mouths tight, bodies listing to this side or that?

It is always winter in a nursing home and there is no sweet smell of earth here. The gods, it seems, could care less. It's the state that oversees; there are rules and regulations carried out by kindly women in white with their meticulous documentation.

If Demeter saw her mother with food stains all down the front of her shirt, with her left hand paralyzed into a claw, her hair standing up like straw, would she have said, *So be it?* Would she have said, *The old shrivel and languish to make way for the new?* Would she have sat and spoken calmly, looked into her mother's old brown eyes and asked, *Are you in pain? How are you?* Would she, knowing her mother had no idea, have added, *Is there anything you need?* Would she be able to ignore, or accept with grace, her mother's crazy new behaviors—the popping sounds she makes, the non sequiturs, the obsessive counting, the questions, such as, "Is that my lunch?" as she points to a newspaper?

Or would Demeter have stormed, loud and oceanic, through these corridors crying out what every daughter wants to cry:

> How can this be, how can the mother who carried
> me be so reduced and shamed year after year—
> diapered, clothing stained, hauled in and out of bed
> with machinery?

Would Demeter overturn the carts standing in the carpeted hallways with their tiny paper cups of medicines? Pull the tubes out of the oxygen tanks, tell the poor nurses aides to bag it and go home? Would she get onto her knees beside her mother's paralyzed legs, her useless white sneakers, kneel there and scream out against Zeus, Hera, any god? Would she lift her mother up and carry her on her back out of there, fly her to a mountain top where she can hold her and let death have her, death which would be kindness compared to this? Would she raise a fist to anyone who attempted to intervene—a bird

with food in its mouth, a do-gooder with an idea? What would she have done, and what would the ancient chorus have made of it?

> **Chorus**: The gods are merciless here, without power to bless as the bodies of old women refuse to let loose their roots. Some no longer see friend nor family. Hear the cries of one, *Help! Help!* Who hears her? Where is her daughter? Her son? Which god has placed his heavy hand on these backs, pressed hard, curved them over and down toward earth? What will the brave children who come here learn to see? Towards which god will they turn?

This is what I do. I keep visiting my mother and trying not to cry in her presence. I attempt simple observation—the guy walking with his mother who clutches a walker with a big Ernie Muppet doll attached to the front of it, like the figurehead on a ship. Another, weighing in at about seventy pounds, flat on her bed, her legs like twigs, food dried on her lips. A woman wrapped in a bright afghan, only her white hair and dull eyes visible. Or the sweet smiling one who has her wits, but almost no use of her body, and has to ask an aide to turn each page of her mystery novel for her. Or the one who chants "nurse! nurse!" Or the mute one with the sweet smile suffering from M.S. who tilts over the side of her wheelchair. Or the one with a stroke who does nothing. The one who won't stop droning "Help! help!" The pair who sit forever blank-eyed, at the nurses' station holding dolls to their flat chests hour after hour.

I stay for about half an hour, that's it. But the images, like ghosts, trail me home and replay in front of my eyes. There is a big howl in me. It is louder than the sounds of the washing machines in the basement that churn and clean all those soiled clothes with names in them on labels with indelible ink. It is bigger than the tall oaks outside the windows there, and stronger.

But I do not howl. I work hard, I try to eat, I sleep. I return to watch my mother make *pop-pop* sounds with her mouth, and I smile at her; I act the good daughter she raised.

Mary Magee, a former Metropolitan Opera singer from New York, becomes my mother's roommate, and for a while things grow lighter in that room. One day Bill visits with me in order to hook up the new VCR we bought for Mom so that she can watch the old musicals she loves.

As usual, Ruth's in her wheelchair, her left hand curled like a bird's claw in her lap, her clothing faded from the hard laundering. Mary Magee is lying in her bed. I heard from one of the nurses that Mary, who has Alzheimer's and is in her late eighties, has stopped eating. A container of Ensure sits on the tray next to a plate of mashed potatoes, carrots and turkey, cups of ice-cream and coffee.

"Have some lunch!" Mary calls over, nodding to her tray.

"No, Mary," I say, "you eat."

"I'm not hungry," she replies roughly, crossing her hands over her chest. There's nothing to her. She's flat as Gumby.

When Bill finishes hooking up the wires and fiddling with dials, he asks, "What should we watch?"

My mother is too confused to know TV from real life. She doesn't answer. I get up and look through the selections of movies on the shelf under the TV, movies she used to watch with my Dad in Florida.

"Here's a good one." I wave *The Music Man* above my head. "Remember this?" I ask Mom as I show her the picture on the box.

"Of course I do," she says righteously.

I position the TV so we all can see it, and settle back on my mother's bed. Bill sits at the edge in front of me. Robert Preston is the "Music Man," Professor Hill, a traveling salesman, a con man, who comes to a small town in the midwest to organize a band. There he falls in love with Shirley Jones, "Marian the Librarian." Professor Hill is all vigor and tanned

muscle. Marian is all lips and face. Red hair too. An ample bosom; it was a *bosom* then.

There are huge production numbers with dozens of dancers and singers. For a while the camera angles down on all of them from above—circles of petticoats and dashing top hats dominate the screen. Then there's the scene on the bridge, the romantic climax. The Professor's been after Marian to meet him there, but she's scared. It seems that meeting on the bridge is a euphemism for "a roll in the hay."

Then in living color, there they are on the bridge and Marian opens up her red ruby lips. Staring with the innocence of a great new love, with the avid expression of an acolyte, she sings the song the Beatles later popularized:

> *There were bells on the hill but I never heard them singing,*
> *No, I never heard them at all, 'til there was you—*

Marian gazes up at the Professor with all that soft promise. Damn it, I've begun to cry; I move behind Bill so he won't see. Then I hear him sniffling. He turns around and nods for me to look at my mother. She's humming, smiling, she's in heaven.

> *There were birds on the hill but I never saw them winging,*
> *No I never saw them at all, 'til there was....*

Stiff with Parkinson's, she turns toward me with difficulty, points a workable finger at me, clamps her eyes on mine and sings.... *"YOU!"* At this moment her eyes look as radiant and alive as Marian's, only older, and I realize that no one, not a soul will ever love me as she does, will ever point such a finger my way to emphasize, *"'til there was **you**."* Not my husband, sniffling on the hospital bed with me, not my kids, not one soul.

I get up. We hug, which means I bend over and surround her with my arms because she can't hug back. Then I kiss her, first on one cheek, then the other. Next she kisses me back,

hard and long on my cheek. Over her shoulder I see Mary Magee singing, her voice high and soft, tears dripping over the bones of her cheeks. I go over and kiss her too.

"It's a love fest!" I say aloud.

≈18≈

Step on the crack, break your mother's back.
Step on the line, break your mother's spine.

We lived so closely in our small apartment. Is Mom there? Inside the porcelain cigarette box with a gold horse, tail flying, painted on its lid? Under one of the cushions on the green couch? Inside an elaborate floral tea-cup placed inside the mahogany breakfront with its latticed wire panel doors?

Is she in the kitchen, a polka-dot apron tied around her waist, her hair thick, dark brown verging on black? Is she cooking another dull and healthy meal?

There must be an elemental essence that contains her.

Is it Air? We lived up in it. Second floor. Open the windows and let it in, good and fresh. See the dark bones of the fire escape, the brick of city buildings, soot from the incinerator on the window sills, my mother wiping it off with her tired dust rag. Once the parakeet flew from the open window, its blue lost to a greater blue. *I want to fly too*, I thought, *it's too small and tidy here, I can't breathe.*

My mother in my chest, the bellows she holds letting air in and out, in and out, but only so much. My asthmatic sister struggling night after night to breathe as I listened and softly inhaled, exhaled.

Fire? The blue flame of the gas stove. Sometimes Mom would ask me to light it when I got home from school. "A very

low flame," she instructed, was lit under the potato baker. It was a small dome-like affair in which she'd already placed four potatoes, skins well scrubbed so we could eat them for their vitamins.

And fire in my sister's tantrums over nothing at mealtimes, her displays. Fire beside the highway, a huge building in flames. I wanted my Dad to stop the car. *Please, Dad, I want to see.* He said, *No, there's traffic, I can't.* Mom said nothing, she stared too. And me, I burned to see something lit, out of control, roaring to extinction as I burned to feel fire, anywhere: in my heart, in the sky, in the eyes of my piano teacher, Miss Green. You'd think her eyes would burn with all that Mozart, that Beethoven. But whatever burned then was hidden, like the pilot light that gave itself so willingly to the four burners, to the four of us.

Earth. How did I know her? Mostly in summer when I was at camp and walked off into the woods. Smells of trees, mushrooms, wet odors of a world the city kept at bay. Mom had a few plants to remind us of it at home. One was a philodendron stuck inside a ceramic sculpture of a donkey. The variegated leaves rose from a sack on the donkey's back. One day I knocked over the lamp stand and the whole thing went flying. Balled up pieces of earth on the Chinese carpet, roots of the philodendron, thin and pale in the light.

"How could you do such a thing?" my mother asked, "How could you?"

It was easy, I thought, just a slip of the foot, a crash of a lamp, just a little mistake. Someone has to make mistakes.

Family vacations provided other opportunities to meet the earth in its varied forms. On one trip to Fort Ticonderoga, New York, my mother exclaimed repeatedly, "Isn't it beautiful? " in a tone of voice I instinctively hated. Wasn't her own enjoyment enough, without coercing me to enjoy it too? Was it her job to instruct my eyes and heart in what to love? The more she repeated the words, the more I shrouded myself, slunk further down into my end of the back seat, as far from my sister as possible. Soon I shut my eyes entirely. Adolescent, sensitive and edgy, I began my own litany of "What's so great

about that?... What's so great about that? ..." At first I said it aloud, softly, but when I got no response, I repeated it in my head for hours.

Now that I know the power of green mountains, bodies of water, skies that unroll indefinitely upward, now that I have my own children, I understand she wanted the whole earth for me, not only our Queens backyard. Her heart was large and her vision went beyond the appearances she was devoted to.

And what of Water? My mother was a strong swimmer. I watched her as I sat on a blanket on the sand at Rockaway Beach. I saw her arms scissor that water as she swam, parallel to the shore, to me. But I was afraid of it, the recurrent dreams of water deluged me at night, waves aiming to kill me. When I was twenty-five, a shrink heard the dream and said, "You are afraid of your feelings." I had no idea what he meant then, but over time I began to allow those feelings and often sensed that I was doing this twofold, for my mother and for me.

19

It was 1956. She was sitting on the green couch. Her hair was still black and she wore an apron over her navy shorts and white short sleeved cotton shirt. On her lap was a pink Kleenex, on the Kleenex a blue parakeet with a blue cere, which meant it was a boy. His name was Twinkle and he had lived with us for two years. He had flown, with permission, around our living room. He had lifted silverware from the dining room table with his beak and tidily dropped it on the floor, much to our amusement. Now he was on my mother's lap and she was crying quietly. I thought: *I've never seen her cry before.* I was shocked, but in my heart I really didn't care because I had

just danced with Bobby Hall, my first slow dance with a real boy besides cousin Ira, who didn't count.

My body felt like someone else's—newer, burning. I looked at my mother, my heart pounding, but I could only see her through its crystal lens. Yet in a remote part of me, I was taken aback, and I stored the memory for future examination because I knew that someday it would matter.

Twinkle was a safe and finite thing for Mom to cry over. He was so small really, maybe four inches long, and he could lie on her lap and she hardly felt his weight. He was the essence of sky—bright, and munificent. He had no history we knew of. Although obviously, like our relatives in New York City, he was not indigenous, but he did not bring with him a history of pogroms or oppression. He was, in spite of his cage, a free agent with wings, nameless until we kids dubbed him *Twinkle*. Like a star, ungraspable and at home in air, until his death, after which we buried him in a green Stride-rite shoe box in the yard.

My mother could grieve for him because he wasn't us, he wasn't her, the child of immigrants who'd lived through the depression, a Jewish woman with worry sewn into the lining of every coat she wore. But never tears, too dangerous. Unloose a few for a dead father, and the dam would break. Unloose a few for my sister with her chronic asthma, and the floods would drown us. Instead, she did for others—constantly, rigidly. The unshed tears formed a salty rod that held her straight and helped her do. Unlike Lot's wife (who must surely have had a name of her own), Ruth did not look back, but ahead at what had to be done: clothing to be washed and ironed, money to be raised, food to be shopped for, meals to be prepared, shows to go to, a few TV programs to watch. Looking back was wet, perilous.

She lived on the edge of a soft, dark body of water, a loneliness. In spite of our closeness, she rarely spoke to me from the deep. Some mothers seem to put their entire selves into their kids, but I always knew my mother had larger needs and ambitions. Did she know what they were? Did she know her own secrets? Only when she was failing and desperate, after

the illness struck, did she begin to confide in me, offer intimacies, show me the small delicate flowers of her secret body and mind. Did my Dad ever hear them? What did she say to him after voluntary or obligatory sex as they lay together? And what of sadness?

Twinkle's death provided an occasion to mourn for what was blue, shiny and could fly, a brand of freedom which could survive in our small apartment. We let him out of his cage often, but he died before his time because one day he flew too exuberantly and crashed into the living room wall.

If I imagine Mom in flight at all, she's in college and excited by the Greeks and Shakespeare, arenas of action, worlds in which tragedy is grand and in your face, like Oedipus blinding himself, then staggering about screaming, blood flooding his cheeks. As she allowed herself feeling though literature and art, she became happier, more alive, and I saw it in her eyes. She got A's, took chances, befriended one of her Education teachers. She was a kite, more brightly colored now, and her marriage, in the form of my father, stood on a beach holding the string, complaining about the sun and sand, saying, *Ruthie, Ruthie, come in, it's time to go home, let's go.*

But for a few years, she didn't listen to him. This was before Florida and his retirement. It was when she had classes, papers to write, and friends, other middle-aged women with brains, to study with. My father, growing frustrated and bored, found some corollary excitement in the form of a weekly therapy group that met somewhere in Manhattan. He'd talk about that group, probably violating all manner of confidentiality and trust. He was, according to his own report, the most healthy person in the group—God, did people have problems! This one with his wife, that with her self image, no confidence at all. It was one of those encounter groups of the sixties, necessary pliers to the shut-tight plastic dioramas of family life in the fifties. My Dad would talk about the group leader, Dr. Somebody, as if he were his assistant: *Dr. Somebody told me after the group that what so and so really needed was blah....*Dad clearly wasn't getting the gist of it, that change involved *self*

examination and disclosure; he never said a word about himself.

Many middle-class people got involved in therapy in the sixties. You didn't have to be *crazy*, you just had to want to *grow*. This is how I got roped into seeing my first therapist. Although my mother told me next to nothing about sex, when I became engaged to Charles, she advised: "After you're married, never say no to your husband." I knew she didn't mean no, as in "no thanks" to the offer of a walk around the block. Charles was an overbearing, albeit essentially good-willed man eleven years my senior. Saying no to sex with him was, I soon saw, the only way I could say no to him at all, and in so doing, begin to define an independent self at the age of twenty. He began to insist I see a therapist because I was not interested in sex, because I was "frigid" (he'd given me a book to read, *The Power of Sexual Surrender*, explicating this Freudian condition and its origins; I remember a picture of a prone, ecstatic woman on the cover). Next, in order to save our marriage, foundering on the icy shoals of my frigidity, Charles insisted that we, or rather I, tell my parents about *my* problem. This, he asserted, would help *me* get over it.

Mom and Dad sat helplessly on the couch, I was trembling and confused, Charles stern. Poor Mom and Dad, they had no idea what to do or say. I might have as easily told them that I'd been having an affair with J.F.K. and I was soon to be the first Jewish woman in the White House, "the first lady." My mother leaned forward on the sofa, trying to understand. Thank God my father began talking about the Dodgers, and how dull baseball was, such a slow sport.

"If you think death means POOF! nothing, or you are angry, of if you think that death is unfair, then don't work with the dying."

I am watching a video of Elisabeth Kubler-Ross talking about children and death at a Hospice training program I've joined at the local hospital, hoping it will help me with my mother. It is a ten-week course dealing with varied aspects of the dying process—legal, medical, psychosocial, psychological. We cover material as concrete as *how can you tell when someone in actually dying?* to the abstract: *what is death?* There is a spiritual panel including local clergy from Catholic, Buddhist, Jewish, and Protestant traditions.

In the video, Kubler-Ross fades then a number of young mothers describe losing their Moms when their own children were still small. Their obvious sadness is consoling to me, as is the exuberance of the kids. One little boy says he has magic and can make his Grandma come back to life again. He moves his arms in intense, angular jabs. *Abra-ca-dabra!* he screams, kneeling on the grass next to nothing visible.

When the video ends, the Hospice social worker says, "Honor the dead, they live with us." Then she covers her mystic tracks a bit by adding, "Who knows?" and gives a little shrug.

I remembered reading in the newspaper how, in remote parts of Japan, shrines for the dead are constructed in homes. One woman served her husband oatmeal every morning by placing it in his shrine attached to the kitchen wall. "He's much nicer now," she reported, "he doesn't yell at me anymore."

Another member of the training, a nurse, tells us that she often gets guidance from her dead father about how to drive, what to say. "The boundaries are so thin," she concludes. She doesn't look at all like someone I'd imagine saying such a thing. Another woman who looks crisp and non-mystic, is my

dental hygienist. When I visit her for a cleaning, and inquire about her Dad, whom she told me was in a nursing home with Parkinson's, she tells me he has died.

As she lowers me down in the chair, I gently touch her arm and say, "Oh, I'm so sorry."

"Oh no, it's fine." She smiles at me as I remind her that I like the gum numbing agent on my upper teeth. She applies it, and then I relax. I like lying down in a comfortable chair in the middle of a busy day with Brenda gently poking in my mouth. We chat a bit between the scraping, when my mouth isn't wide open and I can respond. When she's finished the first quadrant, she takes off the pale blue mask from her nose and mouth, and lets it drop to her throat. She sits on a stool beside me.

"I want to tell you something I've hardly told anyone, it's about my father...." I nod and she proceeds.

My father was so crippled with the Parkinson's that he couldn't move at all anymore, could hardly speak or swallow, and he let us know that he decided that he was no longer going to eat or drink. He was ready to die, and so I asked him if he wanted to come home. He nodded, sort of, yes. I'm living in our house, remember I told you I was going to buy the house I grew up in? Well, I did. So we moved him home. I was told it would take from two to five days for him to pass on. One of my brothers came and helped. He was great.

My Dad was always a really gruff guy, wouldn't let anyone do anything for him, never really showed his love, he was a bear, he wasn't really nice at all, but now, being so sick, he had to let us take care of him. We really did. I took off from work, Dr. Goldsher said take all the time you need. We did everything for Dad, and Hospice came once a day and helped guide us. One day I lay beside him on his bed for about an hour and held his hand. I didn't say anything, I just stayed beside him, and I could feel this closeness, this love. It took him dying to be able to do this, and I know he felt it too. My eighteen-

year-old son was pretty good about it. When I first told him that grandpa wanted to come home to die, he said, "You must be kidding me," but a few moments later he came into my room and said it was okay. He asked only that once Grandpa died, we get him out of the house fast, and I promised, that seemed fair.

One day we brought my mother, remember I told you she has Alzheimer's and she's at another nursing home? I nodded. We brought her back for a big family dinner. Dad always adored her. She didn't know who he was, but once we explained that he was her husband and very ill, she held his hand and sat beside him and kept him company. At one point, she got up and went into another room to eat, then she walked back into the room, looked at Dad and said, "You look just like your father," which was true, my Dad did look exactly just like his father. Mom was pretty agitated, but she wasn't completely out of it.

On the fifth day, actually it was around one in the morning, we could tell that Dad was dying. We watched his breathing grow more and more shallow. Then he began turning blue, beginning with his feet, that's what they do.

"Was he in pain?" I asked.

Not at all, he seemed in no pain at all, it all seemed absolutely natural. We watched the blue as it began coming down over his head, he was bald, and then all of him was blue except the area around his mouth, which was still white and his lips were pursed, kind of like a bird's and he took in these little, little breaths. My girlfriend, a nurse, was sitting right behind me in the room, it was comforting to have her there. My brother and I were holding Dad's hands when he passed on. As he died, and this is the part that is so amazing and hard to talk about— I don't want people to think I'm crazy, I get a feeling they wouldn't understand, but just as he died, I felt this rush of energy and my whole body began

shaking. And then, after a few minutes of that, I was filled with a sense of peace that was better than anything I ever knew, just telling you about it now makes me feel it again. I can't describe it, but it was the greatest gift I ever received from my father, and I'm not afraid of death at all anymore. And now I go to church, I'm Catholic, and I go there now because I can feel the peace there now, as I do now telling you about it....

We sat with Dad for a few hours and then got him out of the house before Jason woke up. "Where's Grandpa?" he asked, and I explained.

It was, she concluded, *as if Dad's soul needed to use my body as a conduit out of his own. It was the most amazing gift I've ever gotten.*

I suggested that she consider Hospice volunteer training. "You seem to have a knack for it," I said, and smiled at her as she pulled the mask up over her nose and mouth, picked up her tools.

My own Hospice training continues. At another memorable meeting, we are asked to participate in an exercise to help us understand what it feels like to die. On a piece of paper we are to list: 1. the four most important people in our lives; 2. the four most important things we own; 3. four activities we love to do; and 4. four roles we play, such as mother, or teacher, friend, partner, lover. We tear up a large piece of paper into small pieces; on each scrap we transcribe one of the sixteen things we have originally listed.

Next we must choose one thing from each category to relinquish. Then two more from each category are randomly snatched from us by the Hospice trainer, whom I glare at thinking, *Ms. Death*. It becomes quiet as she moves around the circle we have made with our chairs and busily snatches kids, husbands, wives, the ability to walk, make love, to garden; she takes houses, cats and rings, she takes cooking and books and music and cars.

"Remember, it's just an exercise," she says, "you can have it all back in a little while."

I stare at my lap. All I have left in the end is my son and the ability to walk. I think, of course, of my mother—no house, husband, walking, meetings, cooking, phone calls. All the things that defined her. And I could go on and on because she was fortunate enough to have a lot to lose. On the other hand, I glimpse something biblical and majestic in her new poverty. Like Abraham, his hand poised just above his small son's white neck; or Ruth sacrificing life in her homeland to be with her mother-in-law, Naomi, in exile. I think of faith, and abiding, of my mother, respectable and human, sitting in a sagging circle at the nursing home listening to Scott Joplin.

The exercise haunts me. For days, I feet anxious, a persistent, existential fear about what is to come, for her, for me. I re-read the beginning of the *Inferno*.

> *In the middle of the journey of our life I came*
> *to myself within a dark woods where the straight*
> *way was lost. Ah, how hard a thing it is to tell of*
> *that wood, savage and harsh and dense, the*
> *thought of which renews my fear! So bitter is it*
> *that death is hardly more. But to give account of*
> *the good which I found there I will tell of the other*
> *things I noted there.*

So many questions doggedly press in on me: Will I ever make it out of this familial darkness? Will I come to terms with my mother's dying, and my own? These are middle-aged concerns, particularly when you've had kids early and they are out of the house. Particularly if there is wide, quiet space around you.

I feel as though I'm on a ledge, as I was in the dreams I had as a kid, the ocean heaving toward me, and I'm afraid. But those dreams stopped long, long ago, and I've navigated raising two kids of my own, I've swum off toward so many destinations and returned, salt water dried on my skin. What I need now, I keep feeling, is another ledge, and faith, which is the energy to jump off from it into the unknown. I write circles around a fear dying to become belief.

I was always an avid girl, and I still want to keep dancing to the song my mother's father, my immigrant grandfather, sang to me as I sat on his lap and clapped:

1-2-3- America is Free
3-4-5- Our country is alive
5-6-7- Freedom has been given
7-8-9 The liberty is mine

As a Jew, I was raised to look up and fear God, but watching my mother die, I began to sense the antidote to fear in earth: female, large, passive and receiving. God the mother was not allowed into the synagogue when I went there. This, however, is slowly changing as the feminine more fully enters Jewish ritual with women Rabbis, women counted for the minyan (the required number for formal prayer), blessings that include the female aspects of creation.

I look up at the stars and try to conceive of millions of galaxies. Perspective. The vast space between earth and other worlds. Put enough space around any pain, and it will dissolve into that space. Put fear into that space, and limitation—my body on its way to no longer menstruating, as big a change as when it began and I was a different girl with two parents. Put death in that space.

In a dream one night I'm told by a wise man that the love I fear losing with the death of my two parents will be given to me by my living community.

I awaken and Bill asks, "Can I brush your hair?" He has never asked this before.

"What?" I say. We're sitting in bed early in the morning, and I've just awakened from my dream. The trees outside are shadowy in the new light.

"The white hair on top is beautiful," he says, stroking it.

Do I inflate my losses? My fears? I grew up in an era when we were issued dog tags with our names and addresses imprinted on them. With them hung around our necks, we dramatically took cover under our desks in school because the

Russians might be sending over bombs. And, in the aftermath of the chaos of World War II, we took cover under our roles at home.

> Take cover. Pretend you are a perfect and happy girl. Take cover. Crouch under the desk of being a satisfied and happy mother. Take cover. Have your hair done at the beauty shop every Friday. Have your nails filed so they won't snag or scratch, have them painted pink. Take cover. Shut up. Take cover under the vast, flat desk of the nuclear family. Must not need. Must be good and strong. May not ask. Calamity the only circumstance under which asking is sanctioned. Categories of calamity? Death by illness, death by nuclear attack, death by genocide, or excessive optimism. Addendum: Never speak of death, it might kill you.

∽21∾

The time, the mid-fifties. The place, New York City. In one small apartment, a television set. The program, *The Arlene Francis Home Show.* On the screen, broadcast nation-wide, were my mother and father. Ruth looked serious. Black dress with short sleeves, no jewelry. Her dark hair with its neat pompadour. Carl looked like a preview of Woody Allen— same black rim glasses, prominent nose, a tense smile. I am thirteen years old, and I sit cross legged on the itchy rug watching, my heart pounding.

Arlene Francis introduces them to the viewing audience; hundreds of thousands of people across America are staring at my parents. They look strange; their voices are high pitched and tense. My mother sits up even straighter than usual.

Arlene Francis explains that a contest has been held to determine which woman across the United States has done

the most for her community. My mother, selected from thousands of entrants, has won. She won because her friend Elsa Rael wrote about her. Elsa has received a new hi-fi, my mother a trip to Paris for herself and my father.

Jules Munchen, a comedian, takes the stage and pretends to be French. He wears a beret and speaks with an exaggerated accent: "And zo, my frrriends, we go to Pareeeee." His R's are so guttural it sounds as if he's getting ready to spit. Arlene Francis laughs elegantly. She is wearing a light-colored fitted suit, slim about the waist. She is bright and breezy and, beside her, my mother looks like an immigrant from a village in eastern Europe. She decided to wear a dark dress to make her look more slender because someone at NBC told her that dark colors on TV make you appear slim.

Elsa Rael makes a brief appearance. She has a harelip that was sewn crookedly, and it looks worse on TV than it does on 79th Street, where we live. I think to myself, how did this all happen: my parents and Elsa on TV? It must be kind of a miracle. I knew Elsa was a writer, but now I know she's a *good* writer because her words won a contest. She explains to the viewing audience why she wrote *Dayenu* about my mother. She says that at Passover, Jews thank God for doing many things to help us get out of Egypt and give up our terrible lives as slaves for Pharaoh. She tells all of America that at Passover, we say, "If God had only brought locusts to the Egyptians, *Dayenu*, it would have been enough. If God had only brought frogs, *Dayenu*, it would have been enough. If only He had killed the firstborn, *Dayenu*, it would have been enough." Then she changes the subject to my mother. She picks up the paper that won the contest and with her funny sewed up mouth reads:

> If only Ruth Zeiger had only been membership vice president of her local Hadassah chapter, enrolling fifty new members in a few short months:
> *Dayenu, it would have been enough.*
> If only she had been a girl scout leader:
> *Dayenu, it would have been enough.*
> If only she had been on the local school board and represented that board at the state capital:
> *Dayenu, it would have been enough.*

If only she had been active in the synagogue's sisterhood which created and subsidized a local community center,
Dayenu, it would have been enough.
If only she had rung doorbells, house to house, block to block soliciting funds for medical research, such as the Mother's March on Polio:
Dayenu, it would have been enough.
And most important for any woman, had she merely been a loyal helpmate and companion to her adoring husband; the warm and understanding mother of two teen-aged girls; had she only kept a home filled with love, goodness and Godliness:
Dayenu, it would have been enough.
Were she only, to us in La Guardia Hadassah, our inspiration, our guiding light and knowing heart; were she only the gentlest, the kindest, the most womanly of women:
Dayenu, it would have been enough.

Then Arlene Francis congratulates my Mom as my Dad watches. She says, "I understand you were a chiropractor." My Mom nods authoritatively. "You must be very strong," Arlene Francis adds. My mother shrugs a bit, smiles and says, "Not really." Then Arlene Francis asks my father, in front of a billion people, what he does. Dad says he's the manager of *Keg-O*, an electrical fixture business. He says my mother couldn't really become a chiropractor because she got married. Arlene Francis asks him if she works on him as a chiropractor. He nods yes. "She's very good," he adds, although I never remember seeing her crack *his* back, just mine and Susie's.

Next a man with a French poodle dances and then we see a picture of an airplane taking off for Paris. My parents stand up and have their hands shaken. They remind me of little children, and I think of analogies I learned in school: *door is to house, as mouth is to body;* that kind of thing. I think: *Arlene Francis is to my parents as they are to me. Bossy.*

How submissive they seemed, diminished by so many lights and cameras, yet oddly dignified. My mother standing

straight, my father with his rigid mouth and those glasses. I remember the wonder of their being on screen where, until then, I had only seen the exotic and unknown. Anything could happen in this world, I realized in a flash as I glanced at my grandmother smiling beside me, her hair braided and pinned on top of her head. Her black thick shoes, her apron. Anything could happen. Yet I was still sitting in our small apartment, and it was still a school day, although I'd been allowed to stay home to see my parents on television.

My mother looked so proud and determined on TV. Was she not also a bit ashamed? Didn't she feel too much the immigrant in that black dress, with her plain dark features? If this were so, her dignity overrode it, as it seemed to always override obstacles. She stood up tall and did it right. Another sort of miracle.

Anything can happen. My grandfather had disappeared two years before. Soon after, I learned that he had been hospitalized because of *senility*. He'd grown angry and unmanageable. No one spoke of it, but it happened, and when we drove past Credemore Hospital, large and gray beside the highway, I knew he was there. There were bars over the windows. I imagined him in a bed, something like the bunks in *Stalag 17*. Anything could happen. He had been a kind and gentle man, a religious man, and then he'd become a mean and crazy one. He'd shaken the bible over his once sweet head, as if he were an angry Moses coming down off Sinai. He yelled at me and my sister, as if we were the bad people dancing around the golden calf. Once, when I walked with him to the candy store to buy a newspaper, he turned on me, screamed, *shikse*, then ran away down the street. Anything could happen. My mother, alluding to his decline, swore that she'd stand on her head daily to increase the circulation in her brain; she wasn't going to get senile. She was always healthy. Never the flu, never a headache.

Now, forty years after watching *The Arlene Francis Home Show*, I am back visiting her in the nursing home. "Hi, Mom," I say.

"I love you," she says, kissing me. "I love you so much."

"And I love you," I say. "You know what? I brought a videotape of when you and Dad were on TV."

She looks blankly at me.

"Do you want to watch it?"

She nods.

I put the tape in the VCR and sit down on the bed. "That's you," I say when she appears on the screen.

She smiles weakly.

"And there's Daddy."

"Yes," she says. And when Jules Munchen does his Frenchman imitation, she laughs.

Unlike her father at the end, my mother is sweet. *It is enough.* She is well liked at the nursing home, a favorite of the aides. *It is enough.* She has pictures of her family on the walls of her sunny room. *It is enough.* She readily says, "I love you," and means it; you can tell by her eyes. *It is enough.* I hold her one good hand. *It is enough.* The screen flickers, and voices from the past fill the air.

<center>❧22❧</center>

The nursing home calls to tell me to come get my mother's make-up.

"She's painted her eyelashes with nail polish," Chris says, "it's dangerous."

"No joke!" I answer.

"We brought her to the ER to make sure she didn't really do some damage to her eyes, but she checked out fine, there's just some irritation," Chris concludes.

I hang up and think: another thing to be added to the list of "no more's."

Ruth loved her lipsticks and beauty aides—her eyebrow pencil and mascara, her rouge and face powder.

Next day I visit and gather up the sad array of cosmetics into a zippered bag. There isn't much there, really. Then I pull up a chair and sit in front of Mom. The whites of her eyes are a bit pink. I stroke her beautiful wiry hair, her cheek. She doesn't remember what happened, nor will she miss this stuff.

As I leave, I joke with Chris. "I brought Mom a video of the Marx brothers, *A Day at the Races*, maybe it will inspire her to do even wackier things."

I drive the cosmetics home on the passenger seat beside me, trying not to look at them. Their image holds so much of her past, her "look good tools." For when she went out with Dad on Saturday nights, her mink stole over her strong shoulders; for when she presided at meetings; for when she danced and sang in shows; the lipstick for whenever she went out.

I think about burying them in my yard, of saying a sad and glamorous prayer over them. But that would be crazy.

≈23≈

I'm a voyeur watching a woman about my age talking to an older woman, obviously her mother, in the fiction section of a local bookstore. They are arguing over who will pay for a copy of Edith Wharton's *The Age of Innocence*. The mother's white head is bent over her inevitable dark purse, as my Mom's always was. She pokes and mutters until her daughter insists upon paying; "You're only visiting for a short time," she says, "it's my pleasure."

I want to tell them how lucky they are to have this time together. It's just an ordinary moment, a mother and daughter having a loving disagreement, but I am envious, filled with

longing for a mother who still has money and opinions, longing for a horizon filled with time to argue and reconcile without the shadow of mortality marring the view.

I remember past visits, some of them too long, some of them bad, such as one my sister and I made to my parents in the mountains of Vermont years before, when they were still living in Florida and had rented a time-share condo for the month of August.

Mom was already walking with difficulty and not remembering. The phone never rang, although they said that many friends from Florida were in the same complex. One evening we watched the film *ET* together; Mom was transfixed.

My sister had brought along a baby-sitter, Mary, to help with her year old twins. With Susie's permission, Mary, a vegetarian, had eaten two bananas from the large platter of fruit on the dining room table.

A few minutes later, I found myself downstairs in the damp laundry room with Mom. "The greed of that girl—eating so much of the fruit! It's terrible," she said, "it's wrong. She ate *three* bananas."

"No, Mom", I said, "she only ate two."

I stepped back and looked at her, so thin and tight, the damn Parkinson's. The pounding of my heart was augmented by the smallness of that fluorescent lit space. I felt angry and defeated.

"Sweetie," I said, regaining control of myself, putting an arm around her. "Don't worry, we'll get more bananas later."

She kept shaking her head.

Earlier that week, she and Dad had stopped to stay with Bill and me on their way up to Vermont. One morning I was in my old purple chenille bathrobe making tea when Mom entered the kitchen in a faded pale blue nightgown. A faded pastel pink towel was over her arm and dangling beside it was a plastic cosmetic case with her toothbrush, cold cream, Stimudents, and medications. It was early and I had been enjoying some solitude before the day began. The light entering the small kitchen was faint, crowded by the giant maples that surrounded the house. Deep summer, leaves heavy with green

making tattoos on the kitchen table and floor. A nuthatch pecked at the bark of the tree just outside the small window over the sink.

"I need to talk to you," Mom said.

I looked up surprised. Had I ever heard her say this before?

"Do you want some tea?" I asked.

"Not yet."

"Sit down," I offered, pulling out a kitchen chair.

"No," she said, "I just want to talk to you." I noticed how much shorter she was, her white head reaching now to about the top of my shoulder.

"It's your father," she said.

I crossed my arms over my middle and leaned back against the sink. She stood catty-corner to me, a foot from the refrigerator which was cluttered with photos of our family. To her left was my daughter, Mara, playing her flute. Beside that was one of Mom surrounded by her oldest friends, the twins, Julia and Miriam. Mom's dark hair, fierce eyes, red lipstick. The three of them grinning.

"Your father isn't giving me any money," she said, leaning slightly forward over herself.

Again he was *my* father.

"What do you mean?" I asked.

"He always gave me money, but now he won't."

"Why not?"

"Because he says I give too much away to charity. But I only write checks for ten dollars and it gives me so much pleasure, so what's the big deal?"

"So you have no money now, none of your own, no pocket money?" I asked.

"Hardly any, I keep asking him."

"That's awful, " I said, "having to ask must be awful."

"Yes," she said slowly. Her eyes looked glazed, as if they were looking far, far away. She didn't move.

"Are you cold?" I asked.

"It's terrible," she went on, "and you know what?"

"What, Mom?"

"I've never refused your father. Not once. Not now."

I took a deep breath. *Just what I wanted to know.*

"Do you want me to talk to him about it, about the money I mean?" I felt I had to offer something.

"No," she said definitively, " I just wanted you to know."

"Mom, I'm sorry," I said. I was.

"It's okay," she said and turned slowly, robot-like, towards the bathroom. She spent at least half an hour in there as I dealt with the images our conversation had aroused, a pathetically conceived video in my mind. *Sex and money,* I thought, pretty basic.

<div align="center">~24~</div>

The Telephone: Another History

AStoria 4-4725 was the phone in the hallway between two bedrooms and the bathroom in the apartment I grew up in. The black phone on the dark mahogany desk, the phone that diagnosed the deafness in my left ear when I was twelve.

"There's no one there," I kept reporting after answering it. My mother brought me to an ear specialist, who said it was the result of too much aureomycin in the treatment of a bad case of mumps. Nerve damage. No hope for repair.

RAvenswood 1-3428. White phone on the wall at the entrance to the kitchen. Unlimited local dialing. Call your friends there, but no privacy. Calls galore for my mother— a Hadassah meeting Tuesday; this Thursday, Girl Scouts. Or, "How much money has been raised to plant trees in Israel so far?" Also, " *Who* died? *Which* kid broke her arm? How much was tuna on sale for this week?"

I only recall my Dad on the telephone at home once. My sister and I were in our room doing homework, and he was

talking to someone, his voice soft and urgent. Then he came to our door and said, "Your Grandpa died." We knew which one it was, because Dad's father had died of tuberculosis when Dad was only three years old and so we'd never seen him, except in photos. Our other grandpa was at Credemore Hospital because of "senility." When Dad gave us the news, Susie and I began giggling uncontrollably. He didn't say anything more, just looked at us and walked away. We couldn't stop laughing. The announcement of grandpa's death was as odd as the idea of Mom suddenly appearing with a huge red bow pinned to the side of her ankle.

I didn't get my own telephone until I left home and married at the end of my sophomore year of college. My mother called me at least once each week, or I'd call her. The ritual continued after I moved to Massachusetts, and she and Dad retired to Florida:

305-971-1141. Sundays I called, and my father answered:

"Hello."

"Hi, Dad."

"Hi, Babe, how're you doing?"

"Fine." Then I gave a little list of specifics, all fine, and how the kids were fine.

"Atta girl," he'd say, "here's your mother."

"But...." He wouldn't hear that. He'd be calling, "Ruthie" in a loud voice.

"Hi, Honey." My mother and I would share pleasantries, i.e. elaborately embroider "fine."

I simply liked hearing her voice.

The calls to and from Florida were punctuated by visits twice each year: one by us south, the other by them north. One summer day, Mom and Dad pulled into our very rural, bumpy driveway and honked their arrival. I groaned at the unexpected sound. The chickadees flew off. A fox slunk off to its den. I came to the door. My mother was slowly getting out of the car—"Can you believe it?" she hollered before saying hello—"bagels are forty cents each now!"

Dad began complaining that there was nowhere to walk.

"Dad," I said, "the road."

"But it's dirt," he said.

"I always walk on it, I'll walk with you."

"Never mind, never mind." Everyday he'd get into his car and drive a few miles to the small local grocery to buy *The Boston Globe*, then bury himself in it at our kitchen table.

Phone calls after Dad's death:
> "Your mother's fallen. She was waiting for the bus. There are no serious injuries:" a nurse at the nearby hospital.
> "Your mother fell. You'd better move her out of here, she shouldn't be alone:"

A year later at *The Buckley Nursing Home*, we get Mom her own personal line. I sit facing her in her wheelchair. "Mom", I say, "your new number is **773-4884**."

"That's a nice number," she says.

I agree.

"773-4884," I say aloud. She watches my lips carefully. Then she says the numbers with me: 773-4884. We say them over and over again. Maybe forty times.

"What's your number?" I ask.

"77...." Something has caught her eye, she's gone.

"It doesn't really matter," I say, patting her leg.

The phone is useful for a few months. Then she forgets what it's for, then anyone's phone number, or how to press a button for speed dialing. After that, I call her at the nurse's station. "Just a moment, we'll get her for you," a cheerful voice says.

"Hello." Mom sounds very far away.

"Hi," I say, "it's me. Mom, hold the phone up, I can't hear you.. Mom?.. Mom?" Silence.

The nurse's voice once more. "Hello," Chris says.

"Hi," I say, "she doesn't seem to be responding."

"I'm sorry," Chris says, "she forgets. The phone is in her lap."

It's spring, and to prove it, there are dozens upon dozens of old-fashioned frilly daffodils on the side of the road near our house. Thinking of my mother, I pull over and fumble in my purse for the Swiss Army knife I carry, totem of the fix-it-up country woman I'd like to be, rather than the dreamy, mostly all thumbs woman I am. Looking left and right for who might see me, I quickly walk to the bed and cut about a dozen bright yellow and orange ones for a cheery bouquet. Daffodil juice oozes from the hollow stem bottoms onto my wrist as I head back to my car. Two guys in a van pass and I wave a jaunty *la-di-da*, like Annie Hall before she really got messed up with Woody Allen.

Behind the wheel, I realize I've inadvertently set my course and I'll have to go to the nursing home—it's hot in the car and without water, the flowers will die fast. And I'll have to visit when Mom's in bed after lunch, the worst time because prone, she's even more confused than usual. The rails will be up on either side of her bed, the Sinatra tape will be playing, and she will be lying there staring and trembling.

I park in the crowded lot and walk up the back stairs to her floor, press the 9-8-7-6- code to get in, walk down the carpeted hall with its familiar odor, and enter the room. Mary Magee is sitting up in her bed, one side of her johnny off her shoulder, which is thin as a coat hanger. Every time I see Mary, I think it's the last, and there she is the next week, only thinner with the usual can of vanilla *Ensure* sits on her tray.

"Hi, Mary," I wave, "How are you?"

"Still kickin," she says.

It's hard to look at her, that bag of bones, that crone who won't stop. I know her son hardly visits. "It's a long story," he told me recently in the supermarket, "but mainly it's that when I visit her, there's no one home." He goes on: "It's unethical how they keep them alive, you love them still, but it really doesn't help anyone." I look past Mary's bed toward

Mom's, she's not there. After I put the daffodils into a vase with water, I find her down the hall seated in a small circle of wheelchairs. It's music time in the "Not OK Corral." Scott Joplin is playing from a boom box, and five women, most of them bent sideways, vaguely listen. One is bolt upright in her chair, a woman with Alzheimer's who, when ambulatory, often barged into Mom's room demanding, "Where's the train?" There's still that random fierceness in her eyes. She's holding a geometrical object with various colored beads in her hands. She pushes one yellow bead this way, a blue one, that. As I approach the circle, she's the only one who appears to notice.

I greet Mom and wheel her into her room. I ask if she'd like more music. She says yes. "Sinatra?" She nods and I put in a tape. He's singing "High Hopes," with a group of kids joining in on the chorus.

"He has a beautiful voice, your father," she says.

My mother fell in love with Frank when she was in her early twenties. She'd gone to a concert in Manhattan and swooned along with thousands of other young women crowned with those pompadour hair-do's of the late thirties. Soon after the concert, she spied my father in the offices of *Leviton's*, a vast electrical parts manufacturing plant, where they both worked. Across the wide expanse with its rows of desks, Ruth saw the Frank in Carl—slender, jaunty, curly hair. Sometimes Jews and Italians can be easily confused; she fell head over heels in love.

Fifty years later, a few years before the nursing home, Mom, Dad, and I were sitting in my living room. Outside October had made something of Eden on our hill, the colors muted by a steady rain. I wanted some happiness for my mother and so had put on the old music, Ella Fitzgerald singing, *Dancing Cheek to Cheek*. Dad was asleep on the white couch, his head back, mouth open. The room resonated with his loud breathing, a rasping metronomic tune. In it I felt the vibratory tether between breath and death; I heard it from his still slender jaunty body, which now listed to one side because of an arthritic back. He would die two months later.

Mom was listening hard to Ella, her eyes misty as I sat beside her.

"What's wrong?" I asked. I held her hand. It was warm and smooth, as was her wide gold wedding band. "Oh," she sighed, looking out the window where a russet oak held its leaves hard in spite of a high wind. "I loved your father so much," she repeated. Ella sang, *Heaven, I'm in heaven....* as we both sat in that room with the song, with Dad's labored breathing, and outside, the wind, and rain.

Not only was Sinatra ghosted in my father's physical form, but after dinner for years we listened to his *Songs for Swinging Lovers* on the hi-fi, a large boxy affair on four wrought iron legs that sat in the corner of our living room. While my sister and I cleared the table, (or rather fought about who would clear the table), my parents would fox trot over the carpet. That was before her discontent set in—why was her husband so negative, so abrasive, such a wise guy? But then, I knew as I watched, she loved dancing with her husband, Carl.

Now my mother is in bed and I look down into her face.
"Hi, Mom."
"Hi, sweetheart."
Her eyes, those brown stones.
"I love you so much," she says, her mantra.
"And I love you."
Somehow I'm getting better at this. Today it's like looking into a well and not being scared. It's seeing goodness in the dark. My mother's jaw trembles and moves fast laterally. Her left hand is in position, curled around a soft device, a stuffed carrot, to keep it from curling further. She lifts her right arm up in my direction, and I lean over and kiss her cheek. As usual, she kisses me back long and hard. It feels like we are at the edge of an odd canyon as I stroke her hair and she waves her right arm up as if trying to grasp something. I can stare into her eyes and not fall in today. Something has changed, and it is good.

My mother says, "I'm crying."
"That's fine," I say.

My mother says, "I don't know my ass from my elbow."

I tell her once again it's okay, she took care of a lot of people, and now it's time for people to take care of her. I think of the whole machinery of this place—laundry rooms, beauty shop, activity rooms, wheelchairs. I think of cooks, dishwashers, linen delivery people, nurse's aides, social workers, insurance-form workers, Medicaid offices. The web spreads endlessly.

She says, "You told me that once before." This surprises me, that she might remember. But Hannah, once the floor nurse, told me about "windows of lucidity." Poor Ruth, she'd be better off with no such windows now. Her arm keeps waving weakly in my direction.

Those arms were always strong, large compared to her slender body. Adept at chiropractic adjustments, at swimming, at pushing around vacuum cleaners, ironing. Good arms. Arms folded over her middle as she sat in a rare moment of self-imposed leisure on the couch and stared ahead through the thin gauze of the long white curtains out the living room window which faced a small grassy slope.

My mother's friend, Julia, told me once that she thought my father was "over-qualified," and that made him testy. Too smart to be content with what he did for work. My mother was over-qualified too, too sharp and spirited to be happily confined by the roles dictated to her as a woman and by the economic constraints that kept her from opening a chiropractic office. Confined by the too-easy routines, the smallness of the apartment. The music from the hi-fi could only take her so far. A spirit in her that is powerful, fiery, and steady, which, in spite of confinement, miraculously endures, like the little oil for Chanukah lasting beyond measure, and so, as she dulls at the nursing home, people love her. No, more than that, it is often easy to love the helpless; they admire her.

She never hit me; she rarely raised her voice. But during my full-blown adolescent fireworks (most of which, in recollection, seem duds), she started saying, "Everything you touch turns to shit." This translated literally into: *you left your underpants on the floor*, or *you didn't Ajax the tub after your bath*, or *you*

left a plate with jelly stains on the coffee table. I rather liked the shit business. I liked that my mother said *shit.* We were almost in the sixties and she was getting in the groove. I cringed slightly at her words, but I also a smiled at the idea of myself as a retro-Midas turned one hundred and eighty degrees from the gold, my fingers embracing entropy, in possession of such grand power—turning things into shit—in our tiny apartment, neat as a pin.

She always bought me charms for a bracelet commemorating important events. As if gold could make a second-generation immigrant Jewish family more truly at home in the *Golden Land.* She bought me a heart for sweet sixteen. (Who cared?) A gold ark with a tiny torah dangling from a thin chain inside the filigreed doors to celebrate my confirmation at Hebrew School.

"What do you want, Mom?" I ask staring at her arm.

She looks into my eyes and weeps a little.

Her reaching arm haunts me, as if it wants to get me, or whatever life I represent, her continuance. If it were to attain what it wanted, it would be, I think, *life,* hers emblemized energetically in my eyes, my face, which for now she still recognizes as connected to her own. And I know this gesture, too, will be lost, and I imagine her arm, disconnected from any rational source, wavering and grasping for life anyway. "L'Chaim, to Life," we always said when drinking the sweet dark wine at Passover and other holidays. We lifted our strong hands and arms up, our goblets full.

26

My mother is a flower closing. Her belly button is the center, the point around which the collapse occurs,

bland limb-petals drawing in. Dark hair gone white, color leached from skin, wan face speckled, as with mold, her eyes unreadable. Her shoulders are compressed forward; there is the hump of her upper back, curl of her knees in her wheelchair, or lying on her side in bed. Pale fish-like feet, which she cannot move. At the center of her body, death is pulling on a cord, gathering her in and down. Tugging, like the feeling of menstrual cramps, gravity, grief, or defeat.

How often I have said the words—*Dementia* and *Parkinson's*—names attached to mechanisms that slowly take her away. Depression is a common aspect of Parkinson's; lately she is so sad, with no language for it. She has retreated further, her love cooled.

"If she were herself," I tell Bill, "she wouldn't want to live like this."

"If she refuses food, we don't press her," the nurse says after informing me that Ruth has lost more than twenty pounds in the past three months. I calculate. At this rate, in six months she'll weigh seventy.

Then the doctor calls to report that Ruth has about three months to live, six at most. I ask what he thinks might take her in the end since, in spite of the Parkinson's, her heart and lungs are strong. "Pneumonia is a likely possibility," he says, then asks if we plan to give her antibiotics.

"No," I say, "my sister and I have discussed this at length and decided against it. We don't think that is what she would want." When I add that I am concerned about inflicting pain on her, he reassures me that properly administered morphine will relieve any pain pneumonia might cause. Then I ask him about the feeding tube which I'd heard had been offered her, and which she'd refused. "Do you think she understood your question?" I ask.

"Not really—I'm not sure, but she did say 'no' strongly," he says.

"We don't want a feeding tube," I say, then add, "You know, she was a chiropractor?" Of course he doesn't know this.

"Really?" He sounds impressed.

"Yes, she was," I say.

For the past month I had been having a very hard time with visiting and finally decided that it was okay *not* to visit her weekly. I'd thought clearly about my own children, imagined them in my position now, asked myself if I would want them to visit if it upset them as much as visiting my mother does me. I had answered honestly, *No.* I had been free for one day. Clear. Then this phone call. It's all changed; it never stops changing.

I call my sister and give her the news, explain the renewed visiting conundrum and she tells me, as usual, "Don't visit her if you don't want to." Of course, she always says this, she feels guilty because the burden is on me, the daughter geographically closer to the dying parent. Although I accept the responsibility, sometimes I am resentful and angry. Sometimes I simply think it is the natural duty of the one who is "the light of her mother's life." Sometimes I tell Susie how hard it is, how I wish she were here, and she says, "I really understand." She visits often, tries to share the burden as best as she can. She says, "I want to be with her when she dies." I do too.

I hang up the phone, thinking that dying, the final scene, is dramatic, or at the least interesting, but the process leading to it—how can we show up for the finale, yet skip much of what precedes it?

A friend, who has been terminally ill, is getting worse and I offer to visit him every other week and read to him. He lives a stone's throw from the nursing home and I have to drive past it to get to him. I love reading to Earl. He understands what I read, offers interesting comments, explains his condition to me. I easily give him some of the love I'm now finding difficult to offer my mother. I sit beside him listening to his breathing, inhabiting my own body beside his, grateful for the fat on my thighs. He's grown so thin.

One day I come to visit. I was told to let myself in, and I do. Earl is on the couch and his eyes are closed, his breathing labored, the oxygen tubes, as usual, in his nostrils. I knock on the living room wall to awaken him. No response. I call his name. No response. I touch him slightly, say *Earl* louder. Noth-

ing. Maybe he's in a coma, I think. I go upstairs and call Bill, who is at home. "What should I do?" I ask. He suggests that I read to Earl anyway, that he might hear me. "What!?" I exclaim. I walk downstairs again and nervously listen for his difficult breathing, then go back to the phone and call the Hospice nurse, whose name and number are on the instruction sheet that Lynne, Earl's wife, leaves for visitors when she goes out. I explain the situation to Kathy. She says, "I'll be right over," and I sit and wait beside Earl and his noise. Kathy arrives within fifteen minutes and I explain it all again, then she goes over to Earl, briskly shakes his shoulder and yells, "Earl!" He instantly opens his eyes and sits up. We start laughing, and I explain to Earl what happened. "Oh," he apologizes, "I'm so sorry, I was just sleeping a deep one." Kathy tells me not to worry, these kinds of things happen all the time, she was on her way out anyway. I tell Earl about Bill's suggestion that I read to him while he was out. Earl liked that one a lot.

Then it's back to Mom. Or not back to Mom for stretches. During this period I let people who love my mother less than I do care for her. And I must forgive myself for this again and again.

I fantasize bringing her home, handing her social security check to a private nurse who, with me, helps her die quickly and with more grace. I imagine my mother lying in our guest room. But I can't imagine this. I remind myself for the thousandth time that she put her own parents in nursing homes. But it's like trying to dislodge a feeling so ancient and deep it's unreachable: I am not caring for the mother who birthed and loved me, whom I ought to accompany all through her dying.

"I'd shoot myself in two days," I tell a friend.

I think of the awful nature of her passing, if she only knew. Does she know? I tell Mom, "When you die, I bet you'll see Daddy." She opens her eyes wide, then mumbles, "I just saw him."

A war resumes. Perhaps it is a war that will end in three to six months. On one side is my small self, a coward who wants

to hide. She is the tender one who cannot bear the smell of the nursing home, the sight of deformed and shriveled bodies, the animal sounds, irrational and mournful. This self cries often. She will always be too young for this world, too sensitive. She was told this constantly by her mother, she is *too sensitive.* Opposing her is the conqueror, she who strides out, constantly takes on and wins. She says, *drop by, visit, it's no big deal!* She bullies, she's impulsive, pushy. *What kind of daughter are you?* she chides. *A scared one*, I say. I tell her that my mother wasn't always nice to *me.* I dream up excuses. I get mystic, pleading. I say that I'll pray for my mother, visualize her peaceful in other realms.

The argument runs on and on, like a Russian novel with so many characters you're lost. With philosophical sidebars. Political tracts. Religious arguments. It is endless, this subject— to visit or not to visit. It is metaphysical, psychological, diabolical. It is the arena in which my angels and devils crowd to have it out. "Be strong," a loud voice says. But whose voice is it?

"It doesn't matter if you visit or not," the counselor says, "so long as you are at peace with your choice. Your mother won't remember."

"But I will," I say.

My friends offer conflicting advice, and my own inner guidance only confuses me as I wait for my mother to die; I dread her dying, and I can't wait for it. I call for a truce between my people—she who won't visit, and she who must. We will confer each week. We will continue to do our best. Haven't we always tried to do our best? We will listen, one to the other. We will make plans, break them, make other plans. We will not impulsively drive up to the nursing home and march in. We will talk. One shall be mother to the other. We will get through, somehow. There are larger issues involved here than the question of visiting or not, and they will take far longer than three to six months to resolve.

In temple mornings we sang, *How goodly are thy tents O Jacob, thy dwelling places O Israel*—- this dwelling place is wet and full of confusion. And now I know that inside each of us

there is not a single dwelling place, never one, but many, and they change all the time.

When I was a child, death was a monster that entered my bedroom each night. It was the rattle in my sister's asthmatic chest three feet from where I tried to sleep. I lay there in body, but really I was at the bottom of a long, dark chute with slick and oily sides. I fell inside it every night, my pink nightgown blown up around my head, my tubular body cold and wet with fear. No sound. Space too vast, yet too confined for a whine or a scream. No one but me falling, falling. I never called out for my mother, I knew better. My sister's cries were what mattered. For me, it was a *Henny Penny* scenario, the sky wasn't really falling. My body was healthy; it was only my imagination that was overblown. And so I was silent.

"Daddy has a heart murmur," Mom told me, "that's why he wasn't in the war. And that is why we must never, ever disturb his sleep, his heart needs to rest."

And so I kept falling alone into nothing, alone into the idea of not being. And because I could not fathom this, my fall never ended. I could not imagine that the world could exist without me, the sting of me—my teeth, my breath, my eyes. That idea of vacancy was so loud it was inaudible, so big, it was inconceivable. I quaked in that spaceless space alone.

When my own son, Josh, was about ten years old, he too went through a struggle confusing sleep with death; he was afraid. I sat beside his bed each night, patting his back, listening. Then he graduated to a radio with a device that shut it off automatically. He fell asleep to human voices and awakened to them in the morning. I remember one of them vividly. I was downstairs in the kitchen fixing breakfast; it was a school day for the kids, cold and still vaguely dark. Outside, the hemlocks loomed and I could hear the voice of the stream running beside our house.

"Ma!," Josh yelled. "John Lennon was shot, he's dead." I immediately began crying. "Stop it Mom," Josh said, "it's silly, you didn't even know him."

At my request, Hospice comes in to care for my mother shortly after the doctor's three to six months prognosis, and she responds immediately to the increased loving attention, begins to eat better, gains weight. I appreciate the new sense of being on a team with other caregivers, of no longer being alone with her. Happily I am able to visit more often.

Two months pass and then, because of regulations regarding length of authorized care, Hospice must leave. If we use up all her allowed time now, when she enters the acute phase of dying, we won't have it. Ruth immediately declines further mentally and physically, losing five pounds the next month. My visits hardly cheer her, and her spirit shrinks dramatically. Part of this may have to do with another small stroke. I am told by the nursing staff that she was found doubled over in her chair. They were, however, able to rouse her quickly, and when they checked her vital signs, she was okay.

As for me, I'm depressed, alone again with my mother, my burden. Then one of my good friends, a nurse, suggests I organize my own private Hospice circle of visitors for Mom. I check with the nursing home, get the green light, and send letters to a number of people explaining the situation and asking for a commitment of a once per month visit. I type out guidelines, provide orientation visits. Several women are glad to do this, not only for me and Ruth, but for themselves. It's clearly not the same as Hospice, but it helps.

When my friends visit her, Mom's condition becomes a bridge between me and them. We grow closer. My mother's helplessness is, after all, the helplessness of all of us in the end, and a tenderness rises from her situation.

As she continues to die, something in me keeps dying amid a continuing storm of feelings. Out of nowhere a wave on the beach approaches and knocks me over. If I am no longer her daughter, whom is there to please? To answer to? Be happy for? Live for? Oh, I know the prescribed answers, I know those self-help books; I've been reading a few of them.

Rage grows in my belly. I boil as my mother cools; I swell as she shrivels. I've been so good all my life, and this is what I get. And worse, if I am not trying to be who she wants me to

be, the person I've lived inside and become for fifty years, then who the hell am I?

I stare at a postcard that hangs in my study. A stone sculpture. A primitive animal creature, verging on human, stares at me, eyes wide, grimacing, teeth bared, nostrils flared. She's sitting like many poor women in India do, back on her heels, knees up, her breasts touching the tops of her thighs. From between her legs emerges a small replica of herself, wide eyed and grimacing.

<p style="text-align:center">❧27❧</p>

With the idea of her death even closer, and despite Hospice's departure, a peacefulness comes to settle. It is fall, the trees bony, the garden brown but for the hearty green curled kale which resists frost. The winter birds arrive—juncos, woodpeckers, chickadees scalloping the air. I begin seeing again, in my mind's eye, the barred owl that appeared the year before during several snowstorms. It sat, impassive, rooted to a limb of the wild cherry tree outside the kitchen window. Ragged feathers blowing in the snow, it occasionally turned its big head to the left or right. I keep seeing it, not the owl this time, but its image. *Wisdom*, interprets one friend. *Death*, says a book of symbols. Again and again its tattered brown feathers are afloat in the wind, its eyes riveting my own. I conjure the bird, a creature from a place where time and pain are only concepts, a hunter with a strong beak and golden eyes, color of the tobacco that sometimes fell from the Camels my Dad snuck behind my mother's back. Owl says:

> Stay strong and steady, in spite of cold winds full of snow. Root yourself in your body as my claws root me to this tree limb, claw inside to your own wisdom.

Apparition. Tease. Clown. Totem. I leave the owl to its dream tree, and go out to my life.

One cold day in November, returning home from town, I notice a cow standing beside a smaller scatter of black and white on the grass. I stop the car. A calf has just been born. The cow's udders are full, stretched, and streaked with the blood that also leaks from her back end. She is licking her calf vigorously, stopping now and again to look at me, sizing up the danger of my presence. The calf is open eyed and alive. It tries to stand, stumbles down. She licks it again, face and flank; the calf stands, topples forward onto its bent forelegs, then all the way down again until it lands on some brambles. The cow keeps tending it and looking intermittently at me. The calf continues to stand and fall.

I don't want to ever stop seeing this, I say to myself. It is the opposite of all I have been seeing lately. I want to be the tongue that arouses, the blood that stains, the milk that gives, the calf that hobbles up into the future. But it's cold. My car, its flashers on, is in the middle of Cooper Lane, a narrow dirt road, and a truck is approaching. I get back into the car and pull further over to the side of the road. The truck stops beside me and a young man in a camouflage jacket unrolls his window.

"New calf?" he asks. His teeth are yellow, his eyes blue.

"Yes," I say, "it caught my eye. I think it was just born."

"Did you see it born?"

"No, I missed that part."

"Too bad...do you know the farmer?"

"Yes," I said, "I'm driving up to tell him." I indicate the direction with a nod of my head.

"Good idea," the hunter says, "that calf's gonna get mighty cold out there."

I nod again.

"Say, how's the turkey and deer up here?" he asks.

"I don't know," I say.

"Ever see 'em?"

"Never," I lie, "nope."

"Well, that calf's a great thing," he says. "See ya, have a good day."

"I already have," I answer, nodding at the cow and calf, and we drive off in opposite directions.

"The cold's fine for the calf," says the farmer, Mr. Gould, who's busy mixing cement.

My own job now is mixing too: owl, calf, and the fact of my mother's dying. Right now the calf is the most important ingredient. I think of it, relive its new life, its long skinny legs, the black and white of its furry resolve to be.

That night I say to Bill, "It might sound trite, but I think that if we lived more naturally, saw animals and people dying and being born, I think all this would be easier." He nods in agreement.

What have I ever seen born? Two litters of kittens. My own two kids, (with the help of a mirror). What have I seen die? Nothing but a squirrel I once ran over; it twitched once, then stopped. I've never seen a human body shudder to a stop, never been there when spirit tears from flesh. Now at least I know the signs from Hospice training—the blue coldness of the extremities, the labored, intermittent breathing.

When we were kids, Susie and I wanted a dog or cat so badly that we actually saved up our allowances and bought a heavy ceramic water bowl for one at the hardware store on Ditmar's. We took our mother's red nail polish from the medicine cabinet and painted the unmanifested animal's name, *SU-GE* on the side in big letters.

"I want my half of the cat to be the head and front legs," I said to her, "you got the first part of the name, so you get the bottom to pet."

But Su-Ge never arrived. *LIFE*, then, seemed never to arrive, unless it was the magazine and that, as our childhood chant proved, only went so far:

> *What's life?*
> *A magazine*
> *How much does it cost?*
> *Ten cents*
> *How much do you have?*

five cents
That's life

That was life—an endless loop, it went on and on, punctuated only by pictures: some guy shot dead in a big city; Marilyn Monroe, her famous white skirt blown up by the feisty sexual vapors arising from a manhole cover; a black person sitting at a lunch counter in the South; a couple on a park bench kissing, oblivious to everything else. We saw pictures in *Life* and *Look,* but little of anything in the flesh at recognizable moments of significant transition. We heard no rasp, no cry or scream. Not a curse, the blessings only in Hebrew, foreign words that floated over us, like the clatter of silverware in the background as we ate Chinese food in the restaurant on Sundays.

How could death, then, not seem alien? And my mother's death? My belief in her breathing body was unopposed by any experience, even my own near drowning off the coast of Israel when I visited as a teenager. My belief in her body was the belief in my own. The fact of my breath was the fact of hers. Without her, life was unimaginable, like jumping into the ocean without arms and legs, and surviving.

Again and again sorrow is a wave crashing unexpectedly at my feet. I momentarily forget I'm at the shore, the edge between being a daughter and not, when the water wets me, and I grab tissues, blow my nose, and walk on.

"You were so afraid of the ocean," my mother used to tell me, "we just couldn't get you to go in." Those were the years when my parents rented a small summer bungalow at Rockaway and Dad would come for weekends.

"It was Uncle Ray who helped you," Mom explained, "He stayed with you day after day until you were no longer afraid.... Such a sweet and patient man, he would sit with you at the edge of the water and build castles with you until you got so absorbed you didn't notice the water at all."

My parents had many friends, including a group of couples, "the Brooklyn crowd," whom they'd known since their twenties. Through the years, they gathered monthly to socialize—the women played Mah Jong, I could hear the gentle clicking of the tiles; the men pinochle, I smelled their cigars. One member of the Brooklyn crowd was Philly Gavrin, who had a real *shtick*, a kind of "double talk."

By the age of four or five, like most kids, I understood most conversations, unless they were in another language, like Yiddish, which my grandparents and parents spoke, (mostly when they didn't want me to understand), or Hungarian, which is what Tsa Tsa, my Aunt Toby's friend spoke. Philly spoke English, but when you were listening to what he had to say about baseball, or the weather or something, just when you almost had the gist of it, he'd add something like, "basekaloon kalimball..." and you'd instantly get all *fablunged*, confused.

"Huh?" I'd say, wrinkling up my nose when he spoke directly to me. Once I got so frustrated, I started to cry, and Dad patted me on the head, "It's only double-talk," he explained, "Philly's a kibbitzer, don't mind him."

I didn't mind him, actually I found him amazing, a man with a beefy mouth who spoke crazy and normal in one breath. Ellie, his quiet wife, sat next to him with her blonde dyed hair, her lipstick and long, pretty face. He'd also do his double-talk with wait people in restaurants, all serious, like he's just a normal guy ordering a normal meal: "I'll have the salmon with calloooloosick on the side a rumdum."

And the poor tired-looking waitress, with her slightly stained apron, her pad in one hand, would say, "Excuse me, sir?" Then Philly repeated his order and just when I thought, *phew, he's being normal* (I worried for the waitress), he'd throw in another *palumajam*. Then Ellie would get just a little stern and intervene, "he's just double talking, ignore him. The

salmon is fine," she'd say to the waitress. And I'd let out a deep breath, smile at her and she'd wink at me.

Yet of all my parents' friends, including Ray and Ellie and Phil, I loved Julia best. Many young girls form deep, abiding relationships with older women, relationships far less complicated than the oceanic mother-daughter one. Julia wasn't the prettiest or the fanciest of Mom's friends, but whenever she looked at me, I knew she loved me in a simple, spacious way, which I readily understood. She hugged me, but so did the others—Ellie, Sylvia, Jeanette, Arlene, Muriel. I think it was Julia's eyes that did it.

When I was ten years old, she took her daughter, Arlene, my sister, and me to Broadway to see the musical *Damn Yankees*. When we arrived at the theater, Julia explained to the manager that she was hard of hearing (she was), and so we needed seats up front. Maybe she gave him those Julia eyes, but whatever she did, we found ourselves in the first row staring up at the dancer Gwen Verdon. We watched her and her legs do beautiful, extraordinary things. I saw sweat, sequins, fingernails, make-up, everything close up as Julia sat beside me, her hands in her lap, her moon-like face and bow shaped mouth, her small eyes staring up at the stage like mine. From time to time, she'd cup her hand behind her ear to catch the sound better, and I was glad because it proved my Julia was not a liar. As each musical number began, she'd turn toward me and smile.

Forty years later, while Mom sits in the nursing home, I drive up to visit Julia and her twin sister, Miriam. They are sitting side by side smiling on the stoop of their home in Teaneck, New Jersey, dressed identically in white turtlenecks, royal blue sweatshirts, blue pants, and white sneakers. They have matching snow white hair. I run out of the car and intentionally embrace Miriam first because I love Julia more, have been dying to see her, and I don't want to show my favoritism. I'm also postponing my joy at looking Julia right in the eyes again, and hugging all of me to her. To what is left of her. I haven't seen her for almost ten years.

"You look well," I say.

She gives me her eyes, and whispers, "you too." We hug again. Julia whispers because cancer has taken her throat. I knew that, but now she tells me it has also taken her thyroid, one kidney and her colon. "I almost died in February," she continues. "I was in the hospital for eighteen days. Miriam slept in the room with me the whole time." I look up to see Miriam ushering my sister and her kids into the house.

Both their husbands dead, Julia and Miriam now live together. They started out that way; I remember the story of how when they were born, each three and a half pounds, their mother, my grandmother Mary's best friend, kept them side by side for weeks in the oven.

"I'm so glad you made it," I say to Julia.

"Me, too," she whispers back. "It's a miracle, and you know, it's good to be alive, no matter what. Tell me about your kids," she asks.

I do, speaking loudly. I really want to whisper to her, speak her language, but then she won't be able to hear me.

We chat of this and that and she tells me stories of my mother, some I've never heard before—the sweet potatoes they bought from peddlers on the streets of Brooklyn, how they'd sneak into my grandfather's pharmacy and open his anatomy books in order to see what boys looked like "down there."

"We didn't know anything," she whispers. She whispers lots of things to me, shows me the tube in her neck, a plastic button there. She shows me her eyes as she whispers and whispers, my hands in hers, "Whenever I see you, it does something to my heart." "Me too," I whisper loudly, "I've always loved you."

When it's time to say good-bye, I promise to write. Julia and Miriam will be eighty in a month, and I easily imagine this my last visit. I run to the car, I don't want to make a scene. I never want to say good-bye to her.

Postscript: I call Julia's son and ask that he call me when she dies so I can attend the funeral. I mention that I wrote

something about his mother, and he asks me to send it to him.
I do. He sends it on to her. I know because a few weeks later, I
receive the following message on a huge, Styrofoam backed
happy face postcard:

Genie Dear*****FOR YOUR STORY
You made me laugh
You made me cry
I am just going to love you
Until I die

(And even after that)

A letter will eventually follow:

I started my romance with you when you were one
year old...after all the years of our close friendship,
Ruthie's and mine, it was coincidence, fate or a
miracle that two such close friends gave birth to two
brilliant daughters *exactly* one year apart, same
month, same date, one year later. Genie and Arlene.
Both over-qualified geniuses. One a writer, one an
attorney. It makes one wonder.
I can only say, Genie dear, when you were sitting
next to me and we were talking, you rolled back the
clock.
It felt like I was sitting next to Ruthie. You are her,
and the feeling I had was indescribable.

29

Rabbi Rieser of our local synagogue, and spiritual ad-
visor for Hospice, offers to visit the nursing home
with me. We agree to meet there on a Friday afternoon and I
suggest he bring a prayer book, as well as some ideas for sing-
ing.

"She's not much good at conversation anymore, " I say, "but she can sing."

At three in the afternoon, I wheel Mom into the conference room of the nursing home and introduce her to the Rabbi. She has always enthusiastically loved Rabbis and synagogues, as she loved her own scholarly father. Today yawns keep escaping from her mouth and my guess is she's missed her afternoon nap; she's hardly impressed. There is a dab of chocolate sauce at the corner of her lips. Now I'm the one who wants her to look good for the Rabbi.

"Let's get you cleaned up, " I say, licking the end of a tissue and wiping her face. I remember well when she did the same to me, but without a tissue, just licked her thumb and rubbed my cheek. I look down at her stained pants and scratch at some dried food on her right thigh.

Rabbi Rieser is soft spoken, tall and kindly. The three of us cluster to one side of the shiny long mahogany table surrounded by chairs. It's hot as hell in this little room, but it's private.

The Rabbi and I begin to sing old Hebrew prayers and songs. We try to find ones we both know, which my Mom might know as well, words with familiar tunes and pronunciations. Whenever we hit on one that she seems to remember, her eyes moisten and she focuses them intently on one of our faces, and mostly gets it right. Sometimes she stays with me through an entire song, sometimes with the Rabbi. Occasionally she switches faces mid-song. But she's so obviously tired. She yawns again and says, "Excuse me." I am proud that she says, "Excuse me."

Mom clearly likes *Shalom Aleichem*, welcome in peace, the slow version. Three times she cues us to sing it again by beginning it, a lispy "shhh..." for "shalom" in her weak, slow voice. We sing it over and over.

She also remembers a Yiddish song, which neither the Rabbi nor I know very well, *Afn Pripichik*, "At the Fireplace." It is a song about a Rabbi teaching the pretty children the alphabet. Mom knows all the words and sings them without us, her eyes rheumy and soft, staring vaguely ahead.

"That's beautiful," Rabbi Rieser says when she finishes.

A long pause, and we are in the heightened atmosphere of people uncertain of their roles. We're new at this, and the Rabbi tells me that he will be glad to meet every Friday, that this is a good way for him to prepare for the Sabbath.

We do yet another round of *Shalom Aleichem*: "Welcome in Peace, Welcome the Angels of Sabbath...."

I've brought Mom a red carnation and it's fallen off her lap. I retrieve it and hand it to her. She lifts it to her mouth and the Rabbi and I watch her kiss it over and over again. He smiles.

"Mom, you're really tired, " I say.

The following evening Bill and I go to a local theater to see a production of *Autumn Portraits*. The writer/performer, Eric Bass, works with rod puppets, which he has made. They are intricate and beautiful, finely dressed, with hands that clasp, and mouths that move. Some of them have their own masks—mystery over mystery. The show consists of stories about people nearing the ends of their lives—African, vaude-villian, Jewish.

The last is of an old, balding cobbler, "Reb Zaydl," who is working at his bench when the Angel of Death approaches to say, "It is time." Reb Zadyl ignores the voice and continues working on the miniature leather shoes in his hands. The voice grows louder, the Reb continues to remain deaf to it. He pauses from his handiwork to tell the audience about his life—how his parents wanted him to be a scholar, but, he says, "the books did not speak to me, but shoes, shoes..." he says, "they made music for me." With that, his wooden hand picks up a tiny shoe and he holds it to his ear, listens and sings, "Afn Pripichik: as der Rebbe lernen klayne kinderlach dem alef bes." It is the song my mother sang yesterday for the Rabbi and me.

The cobbler explains that each thing in the world has a voice that must be listened to; this, he instructs, is the way we learn to live correctly, by listening for and obeying the par-ticular voice that calls. Then, suddenly, the light goes on in the puppet's wooden head—each thing must be listened to! Oy! But still he tries to delay the Angel of Death.

"I can't go yet," he insists, "I have to finish these little shoes for Rachel." Rachel is the name of my mother's youngest granddaughter, only seven, and my mother lights up for her now as she does for no one else. Rachel is also my mother's Jewish name.

The Angel of death says, "I'm sorry Reb Zaydl, but it's time, it's time."

Reb Zaydl shakes his head sadly. "I'm sorry, Rachel, " he says, "I cannot finish these shoes for you. I'm sorry." At last, he leaves in the angel's embrace.

Shalom Aleichem. May he go in peace.

⇜30⇝

A Letter to My Mother:

The first thing I hated was you because you were not there as I cried on my back. Or was it the hollow in my stomach I hated as slatted light entered my small white room but didn't fill it?

The first thing I loved was you coming to me as I cried on my back, or was it the fullness in my stomach, the smell of your skin, your two eyes, dark coals, burning above me with perfect heat? Your large hands contained me, circled my middle, then lifted me toward the ceiling or sky.

The first dream I had was you disguised as a deer grazing at the edge of the only field I ever lived in. I saw your jaws moving, heard the sound of teeth on grass, the ripping of more grass. Above you a crow flapped blackly, then I woke to your voice saying my name, Gene.

The first door I opened was your door; the first room I entered, yours. The pillows were rolled

into neat little hills, the bedspread was flat as a sky I knew better than to disturb, and so I climbed under the bed and lay on my stomach in your dark.

The first city I entered was, of course, yours. Fire escapes outside the windows, but never any fires. The sidewalks were hard, the trees planted by hired hands who propped them up with sticks and ropes. There was a fountain outside the factory across the road; waters rose and fell all night. You were the colors that played on the waters—red, blue, yellow—and without you, I couldn't see.

The first time I was alone was because you left. I stared in the closet at the space that would have held your coat and saw only the dark; I heard wings, although I never saw them move. The sound of wings was all I knew until you lit a match, and just before you blew it out, I saw my own face.

❧31❧

I find her lying in bed after her afternoon nap. Her jaw is quivering vigorously from side to side.

"Hi, Mom," I say with nursing home cheer. She looks slowly up at me and says, "Hi" without her usual, "It's my daughter!" and so, missing that, I say, "It's me, Mom, it's Genie."

She stares and at me, and says, "Will you be my Mommy?"

"Sure," I say, "What do you want me to do?"

No answer. She appears to be considering the circumscribed view her body, in its fixed position allows. She can move little but her head, neck and right hand.

"Do you want me to do something?" I ask again, stroking her hair. "Mommy's can do lots of things."

"I want to cry, " she says slowly, "I feel like crying."

I stroke her hair and forehead again. "You can cry all you want," I say. "You hardly ever cried that I can remember," I add, "you cry now."

There is another long pause.

"Yes," she says, "I rarely cried." She stares at me. "I can't cry," she says.

"Well, do you want to go to a baseball game?"

"Yes," she says, "I want to go to a baseball game." There is a small gleam of light in her eyes.

"Oh, I'm sorry," I say, "I was just kidding, we can't really go. But I can be your Mommy anyway."

At this point, two nurses aides come in to attend her, to change the wet bedding, the diaper, to dress Mom and get her back into her wheelchair. They've brought in the Hoyer, a mechanical device for lifting her out of bed. You can do it, I tell myself, and ask the aides if I can watch how the machine works.

"Sure," says Claudia, the chic aide with the magazine face.

I leave the room as they change her, and then come back as the outfitting device is attached around her and Mom is lifted up in a sling, then briefly suspended in the air between her bed and wheelchair.

"She still gets a little scared," says Gail, the other aide, who is not magazine cover material.

I approach Mom joking again, it's a biological reflex in this place, it's called survival.

I hold her hand, gently push one side of the sling and rock her a bit singing, "Rock-a-bye baby." She immediately smiles and sings with me until she is lowered down.

"That's wild," I say.

"It sure helps us," Gail explains, "back injuries and stuff."

Then Gail and Claudia begin to work with Mary, Mom's roommate, who is clearly in a bad mood.

"Let's go somewhere else," I tell Mom. "You hold this." I slip a green, grass-like covered edition of Whitman's *Leaves of Grass* her lap. It's a book she and my Dad gave me when I was in my teens after they often found me reading it.

The TV is blaring in the activities room, and so I wheel Mom to a corner as far away as possible from it. I sit in front of her. Yes, she's out of it today, her eyes vacant. You never know from day to day what you'll find. "It's a crap shoot," as my Dad would have said.

I tell Mom I want to read to her and I begin:

I have said that the soul is not more than the body,
And I have said that the body is not more than the soul,
And nothing, not God, is greater to one than one's self is,
And whoever walks a furlong without sympathy....

Her eyes drift; she's not smiling. Perhaps I'm boring her. A dark woman near us begins loudly moaning, "Nurse, Nurse." An ugly woman, all droop and lips, sways side to side.

"We're out of here," I say aloud, and wheel Mom back to her room. The pink mini-carnations I brought last week have grown brown at the edges. The sun streams in through the windows, and I position us carefully in her half of the room, which is packed with photos of our family, the TV, and an oil painting that has long been with our family. Full of impasto, it portrays an Asian woman combing up her hair, the forever green and orange of her kimono, her impassive flat face that never seems to fade.

"Let's sing," I say. I'm sitting on the edge of her bed, she's facing me in her chair.

"How's *Oklahoma*?"

Nothing.

"I'm putting on *Oklahoma*." I remember her telling me that she and Dad saw it on Broadway when she was pregnant with me. Gordon Mac Rae begins singing, "Oh, What A Beautiful Mornin'." I imagine him in front of some ranch, facing a field, in jeans and a plaid shirt. He's young and vigorous, swinging his right arm up victoriously, as he begins:

Oh, what a beautiful mornin'!
Oh what a beautiful day!
I got a beautiful feelin'
Ev'rythin's going my way.

When Mac Rae gets to the *ev'rythin's going my way* part again, we both burst out laughing.

"Yeah, Mom," I say, "everything's going your way, huh?" She laughs and laughs and nods.

"It's *really* going your way!" I add and she laughs some more, then weeps as the music continues.

"Well," I say, "you wanted to cry.... And, yes, things did go your way for a long time and now, well—" We laugh again, teetering on that red hot edge between pain and joy, the searing place in which it feels that together we're one song that won't ever end.

Song was always in our home, emanating from the sturdy hi-fi in the corner of the living room. Broadway musicals, light classics, leftist songs from The Weaver's *Talking Union* (at five, I knew all the lyrics to "The Union Maid.") I'd sing along with Paul Robeson's purple bass to "What Is America to Me?" Music crumbled the walls of our small living room without making a mess. Miraculous! It was escape, celebration. In a home where voices were never raised, fabulous sounds flowed over the rugs, did cartwheels, made our hearts pound.

My parents both performed in local shows. Mom in line with her neighborhood friends—Jeanette Salley, Estelle Rieff, Harriet Marder, Muriel Bell—all of them in black and red flared mini-skirts, black fish net stockings, high heeled and kicking up a storm. How free and alive she was, sexy too; she had a great figure. Dad played in *The Mikado,* a nylon stocking over the top of his balding head, black eyebrow pencil forcing his eyebrows to angle up towards his temples. Lipstick on his lips. How weird, I thought, how very weird— my parents having fun. It wasn't work and cleaning up and shopping and ironing. It accomplished nothing constructive but itself, and it left behind only folded-up costumes in boxes as well as a few musical phrases that would crop up at unexpected times: washing dishes, driving, walking to the store.

Music helped Mom carry on, her slow dying was punctuated by particular songs, its process revealed by specific yet unconscious choices. She would hit on one and obsessively

sing it for months, the lyrics telling her and us over and over again what needed communication at that time. After my father's death, which marked the severe beginning of her decline, it was a Yiddish song, *Vus is Gevain is Gevain* , "What is gone, is gone, it is not now," i.e. my husband is dead, he won't be back. Words confirmed reality. Her obsessive repetition of them as we walked together, drove, or when I visited her reminded me of friends in the process of divorce, repeating the story of separation over and over, to make it more bearable, real.

Next was "Life is Just a Bowl of Cherries," a kind of a post-Depression era version of the Buddhist idea of non-attachment. A way of her telling herself that the apartment, the furniture, her jewelry, shoes, dresses, all that she owned didn't really matter.

She'd sing this one with an exaggerated rhythmic lilt, affirmatively cheering herself up with the cherries. I liked singing it with her. Her granddaughter Rachel, almost entirely off key, sang it at her school talent show.

Songs are the last memories to go, as hearing is the last sense. Imprinted rhythmically, words remain registered in the decaying brain. As her condition worsened, song became the main vehicle for shared communication. Mom would rivet her eyes on mine, and we'd sing, "Show Me the Way to Go Home," another favorite. There is something notably poignant about a sick, old body singing, the flagrant and moving contrast between message and medium.

The Rabbi and I routinely visit her together on Friday afternoons, just before sunset and the arrival of the Sabbath bride. We try singing different songs and prayers with her, but the only one that consistently crosses the failing bridge to where she is living is *Shalom Aleichem*: *Shalom Aleichem, malakay ha sharay, malakay el—yon*: "Welcome angels, angels of peace, ministering angels." After we reach the end of this ancient song, Ruth pauses, stares ahead into the silence, and then takes it up again, the *Sh* of *Shalom* again slowly issuing from her lips, as if she were quieting the world. Then *Shalom,*

the whole word: *Hello, Good-bye, Peace*. Then we'd all take it up together; *Shalom Aleichem*, welcome angels of peace. As if death were the Sabbath, the day of rest, as if we were welcoming it all—angels in nursing homes, subways, cornfields, angels everywhere.

One of them is Anna. She is thirteen and the daughter of one of my closest friends. She comes to the nursing home each week now as part of her training for her *Bat Mitzvah*. It is the *Mitzvah* part she is here for, the doing of good deeds. I've known she visits, but we've never been here at the same . She walks into the room and her young face is a gift. I notice she is wearing an apricot colored shirt I gave to her mother about fifteen years before, and I tell her it looks great on her.

"I like your Mom," she says as we sit beside a mute Ruth, "she's really mellow."

⊸32⊸

The phone rings at 10:30 P.M.

"Uh-oh," I think.

"Hello, this is Joanne at the Buckley Nursing Home, can you come over now?"

"What's wrong?" I ask.

"Your mother's not doing well, I think it would be good for you to come."

"Is she dying?" I ask.

"I don't know," she says.

What do I bring along besides my thumping heart? What about sleep? Do I call my sister? What about tomorrow?

I find the stone the Hospice social worker recommended for "centering." It's on my desk in the shape of a small kidney. I hold it, stand still, breathe, then gather some food, a bottle

of water, the *Book of Psalms*, and put them all in a canvas bag along with the stone.

Ruth looks lousy. She's propped up in bed, her eyes red and she's coughing. When I ask the nurse what is wrong, I'm informed that without my permission (I am her health care proxy), she has been given a vaccine against pneumonia. (Later I will confront her doctor, and he will apologize, it was a mistake). This crisis, the nurse explains, is most likely a reaction to the injection, but we can't be sure.

Mom is agitated, afraid. She can't say this in words, but I feel it and see it in her eyes. My presence begins to calm her. She did not, I learn later, ask for me to come, but responded favorably when a nurse suggested the visit.

I move a chair beside her bed and hold her hand. It's warm; dying people have cold hands, everyone knows that. I sit with her and let her cough in my face, worrying that I'll catch pneumonia. She is weepy and keeps repeating, "I want to cry, I want to cry...." Again the woman who hardly cried in her life, who never wanted me to cry, is talking about crying. I stroke her forehead and again tell her it's okay for her to cry. Nothing.

"Do you want me to cry?" I ask, trying another tack, "I'm really good at it."

She nods.

I find I can only muster up a bit of moisture.

"I'm sorry, I can't cry well tonight," I say. I laugh, and then she does, but it turns into a cough, a ticklish spitty hack.

The nurse comes back in to check Mom's blood pressure, pulse, and temperature. When she's done, I follow her out and she tells me everything's basically fine.

I go back to Mom's bed and tell her she's okay, she's not dying, and she has another coughing fit. Her eyes clasp mine, as fully as her hand holds my hand again, a bridge built of endurance and memory. I meet her in the middle of that space, solid as steel, created by our four eyes. Then in a raspy, dragged from the bottom of a well voice, she mutters "Shhhh...."

I lean forward. "What?" I ask,

The wet frog sound expands into "Shalom." Guttural, Hebraic.

Oh, I get it, she wants the song again. I begin singing: "Shalom Aleichem...welcome angels, angels of peace." I sing it over and over as her eyes begin to flutter shut. Soon she's asleep and I steal from her bedside to talk to the nurses. We agree that Ruth is not dying tonight, and I head home. It's close to 1 A.M. Relief, and a small spit of disappointment.

This episode is not without its effect and for a while I visit Ruth again without dread. I faced something with her, her fear, and came to feel the value of my presence. I start to miss her if I don't see her for more than a few days. My visits become regular; happily, I am able to couple my love with action.

When I believe I am losing her, she comes back. When I can no longer stand seeing her die demented and crippled, I begin to see her often. The circle turns. I fall into her lap and sit there, and she says, "I want you to be my mother." And I say, "Yes, I'll be your mother" and I stop being a daughter, I give up the ancient idea of her as protector, comforter, source. I grow ten feet tall and wide. I take death onto my lap and say, *yes, okay, you too.*

After my mother rubs the end of her drippy nose, I hold her damp fingers in mine anyway. I keep singing to her, sing my heart out, her hand in mine—*Annie Get Your Gun, Damn Yankees, Carousel, My Fair Lady.* I get my heart back. I get my mother back; and she is my child.

Sometimes I find her sitting in the activities room. Perhaps there are two or three other women there, all scattered at odd angles in wheelchairs. No one speaks. The music has stopped and no one has inserted a new cassette. She sits staring off in the silence, her cloth carrot in her fist. Nothing appears to be happening. I look and see how small the room is, her life. I see how big the space around this room, this building, her almost eighty years.

She's alive because she wants to be. Someday, she will say, *this is enough.* She won't say this with language, she won't think, *enough,* but she will know it, or *enough* will know her.

For now it is enough that we have both come to this place in the circle: the mother become daughter, and daughter strong enough to become mother. We end here where the words stop, before the end.

33

I wanted to end with a neat, classical coda. I wanted to end with the daughter become mother, with peace and acceptance. But as soon as I got to that place, it vanished. Mysteriously, the honeymoon with my mother's dying became a difficult marriage again. Negotiations with myself resume, visits slacken, my health is compromised.

Death doesn't adhere to our schedules, and damn it, I'm still having to juggle four balls in the air—my mother, me, her death, mine. I do well for a little while, and then I drop one, or two. I pick them up and begin again. I juggle and fail, juggle and succeed for a while. Perhaps, because of this practice, I am more balanced, my feet planted more strongly on this ground. I sense holy presences more often within and around me as I try to keep the balls aloft.

Disconnected from language, my salvation, my mother is so sad. When I ask her a question, she tries to reach slowly down toward an answer, and it withdraws.

"Why are you so sad?" I ask. "What can I do?"

I offer the bait, but she's too tired to bite. I want to help, and I can't, and so something else happens; I find myself trusting more and more in the invisible. What I often see in the nursing home is so unbelievable, why not choose to believe that we are far more than these bodies, that invisible beings help us, that another, higher truth prevails? Actually, belief seems to come on its own, like a wind.

Then, once it makes its appearance, our choices can summon it. Into the silence we can sing the angels of peace. *Shalom aleichem*, we sing into that silence, as best we can. We wait and sing and cry, and we sing again, and wait some more. And the ending keeps opening out and becomes another beginning.

<center>⇜34⇝</center>

When I was young, I was old. I stood naked in the pink and black tile bathroom and looked down at my skinny body. It was small, but it was big. Inside it, I knew with the old mind of the very young, was everything I would ever know or become.

When I was naked, I was clothed in the most essential way, by my skin which, like a wind chime, registered the wind, all the sensations that assaulted me from the external world, which wanted only to enter me and live. When I was inside myself, I was outside because light and sound were, I knew, what made me, and in the beginning, I knew I would become them in the end.

When I was young, my mother seemed old. She was huge, her breasts, her eyes like two suns. In her presence, I was warm, and moist. Her smell was my atmosphere, her skin, my blanket. She was, like all mothers, mythic and earth to me, providing food, a place to lie down. When she ignored me, it was winter, colorless and cold, as she could be when I knew that I was not what she wanted: when I slipped my thumb into my mouth and sucked it, when I insisted on wearing my red shirt all week, when I was "too sensitive," when I said I hated.

When she was old, my mother became young. Her body grew smaller, her skin oddly smoother. She had to be in-

structed in managing the things of the world, as she had once managed me.

When she was old, she grew younger and younger, mostly in the reverse of the developmental order that happens with a baby. She needed, for example, help walking: first a hand, then a walker, then a wheelchair, and then only a bed. We skipped the toddling part, the time when she'd stand me, as a baby, up on my wobbly legs, then back up onto her knees, reach her arms toward me saying, "Come here, honey...here." We didn't do that.

She needed help eating—her left hand atrophied from arthritis, she used the right to fork or spoon her food, then her fingers for the same, then trouble came with her swallowing and she had to be fed—first solids, then pureed foods, then only liquids. She had to be dressed—at first she chose her clothing, then she didn't notice, or care. The make up which she'd always worn was removed, the jewelry—the thick gold wedding band, the lovely engraved gold bracelet, the earrings—all put away once she entered the nursing home for fear they'd be lost or stolen. Thank God, I thought, remembering all the time spent hunting for them in Florida and at Peggy's. "I can't find my ring again," she'd mutter, angry at herself, at us.

When she was old, she was young. Her eyes began to speak as her speech diminished; they moistened easily, they said what she could not, and, like the eyes of the very, very young, most often they said, *love*. Either that, or her eyes, like her tired face, grew mute and remote as if they'd entered the ether, the next world where nothing, or everything, had already happened.

When I saw her old, sometimes I became old. Fearful. Tense. Her rigidity entered me and freeze-dried my reactions. I was often unnatural, not knowing what to do, as if I'd entered a foreign atmosphere rather than my own mother's presence. I didn't want to grow old as she had. I told myself, you are different from her, you won't die the same way.

When she was old, she was young, but she was old too. Her sorrows were apparent, in spite of a lifetime of denying

them. I had taken them upon myself for as long as I could, a deal I had unconsciously made when I was young, a deal that had made me old. She'd always told me that I was "the light of her life," and I'd grown muscular and tired carrying that torch. Now that her own light was truly fading, what would I do with my own?

<p style="text-align:center">~35~</p>

On this visit, I find her in bed. A small blue and pink quilt bordered with lace lays on top of the white sheet and standard white blanket.

"Do you know what dying means?" I ask, after the kisses.

A long pause.... "It means leaving."

"Yes," I say, staring into her blurred eyes, "but our hearts will always be together."

"Really?" she asks, her eyes noticeably widening.

"Really," I say, "mothers and daughters are always together in their hearts. Your old friend, Ruthie Weinstein, remember Ruthie, from kindergarten? She told me just the other day on the phone when she called to ask how you were doing, she said, 'you know, it might sound funny, but here I am eighty years old and whenever things are really bad, I feel my mother around, and she comforts me....'"

Mom says nothing. She closes her eyes.

On the way home, just before the turn to my house, I stop to watch a doe and her fawn standing in the middle of the road. They stare back at me without moving for a time, their bodies full of mystery, as if they are moving, even when standing still. Then they both turn their heads towards the woods at once. The bottom of the trunks of the young maples are buried in new snow. The doe deftly jumps over the stone wall,

the fawn takes another long look at me, then leaps and disappears behind her.

⤳36⤳

A week later, I sit with Mom and her vacant brown eyes. Beyond the cotton curtain, Mary Magee lies quietly. Beyond the door, the persistent clatter of life expended in service to the dying. One woman is moaning, almost sexually, in the distance. My mother does not want food today, but eats my eyes, and smiles as we hum with Sinatra on the boombox.

"Mom," I ask, repeating a joke my son has told me, "Did you hear about the new restaurant on the moon? No atmosphere."

No response. I try again. "Mom," I say, "let me tell you a story that you loved to tell about me, maybe it will make you want to eat. I'll pretend I'm *you* telling *me* the story. Okay?" She nods.

> When you were a baby, you had a poor appetite. Who knew why? I, of course, wanted you to eat, all mothers want their babies to eat, they want their babies to be fat-cheeked, like the Gerber babies on the cereal boxes. I tried and tried, I even made you fresh vegetables, fruits. I cooked them and put them in the blender, but it didn't work. I was quite concerned. I even called the doctor, but he had nothing useful to offer. I kept trying, but you clamped your mouth shut, and even the beautiful silver spoon from Aunt Gertie couldn't get in.

(Mom listens intently with a bemused smile).

> One day, Mrs. Ross, our upstairs neighbor, the one whose husband, Milton, sold sheet music, well, she came down at feeding time. You were in your high chair, a bib around your skinny neck. So I

invited Mrs. Ross, Helen her name was, to sit next to me. Maybe she could come up with some ideas—her son, Alan, was a good eater, remember him? So Helen Ross watches you buttoning up your mouth like I was poisoning you, and she decides to try a trick. You see, she had dentures, even though she was only in her thirties, and what she did she do? She opened her mouth, and let the dentures drop off her gums, the top, and you, smart baby, were so surprised to see teeth fall inside a mouth that you opened your own mouth in shock. You were smart. (Here, my mother smiles deeply). And then...in went the food! Helen was a nice woman and would come often; she'd sit down, open her mouth, drop the dentures, you'd open your mouth, and in went the food! And you put on some weight and started looking a lot more, Thank God, like that Gerber baby.

Mom keeps smiling at me broadly, pulls my eyes down through hers into her heart, her belly.

≈37≈

I arrive once more to find her sitting again in the common room, her good hand trembling in the air above her body. I approach her among the others and position my face in front of hers. She half smiles. We kiss and I ask her how she is— she makes a sort of thumbs down motion with her good hand, but she can't really separate the thumb from the hand and so wags the whole thing.

"Not so good?" I ask.

"No," she says.

"Let's go to your room, Mom, we'll talk. Okay?"

She nods and I wheel her in. The sun blazes on her window ledge, which is covered with plants and photos. There's

an odd planter there constructed out of miniature logs. From it rise two skinny red stalks with a few leaves near their tops. I wonder where it came from. There is a plastic cube with family photos on every side, and a framed large color photo of my parents taken about fifteen years ago. Mom's hair is dyed black and she smiles stiffly. Her dress is striped red, white and blue. Dad is mostly glasses, a suit, and a mouth like mine.

I situate her wheelchair and pull up a chair so I can sit close to her in the small space we're allowed. There's a blob of custard congealed on one of the metal rests from which her foot has fallen. Today she wears an aqua and black velour outfit. Her hair is flat in back and poofed up on top. Someone has been fooling with it.

"Mom," I say, "I need to talk to you."

She stares at me, her face impassive.

A minute passes. "Okay?" I ask.

"Yes."

"Mom," I say, "I want you to know that you don't have to stay alive for me or for Susie. We will be fine if you go."

The reason I'm talking to my mother now about dying is that an aide told me recently that Ruth reported she is worried about her children.

I repeat to Mom: "You don't have to stay alive for Susie or me, we will be okay if you go."

"You'll be okay?" she asks slowly. She's on her island off my coast and her words arise from a more distant island.

"Yes," I say, "I hate to see you so unhappy."

"I'm very, very unhappy," my mother states clearly.

"Why?" I ask her. I have my hand on her thin thigh, the muscles tight as metal strips from the Parkinson's.

A long pause. Her eyes glaze mine.

"Why are you so unhappy?"

At last. "I don't know."

"And of course," I say, "it's okay, it's good for you to live. You're so tired," I add, stroking her beautiful cheek.

She looks me in the eyes. "Mother," she says to me slowly, "forgive me, I'm tired, I'm so tired."

"Of course you are. It's been almost five years since Daddy died, and you've been sick. You're in a nursing home, and I'm sorry I can't take care of you in my house." There is a long pause.

"Do you want to live?" I ask.

At last. "Yes, I want to live."

"Why?" I ask her. I'm holding her stiffened hand, my face about one foot from hers, "Mom, tell me why you want to live."

She looks down at her lap and slowly picks up the edge of a white towel I've placed there in anticipation of feeding her lunch.

"Because I love this towel," she says with a little smile.

"You want to live because of the towel?"

She watches me closely as I blow my nose waiting for her answer.

"I love my nose," she says slowly.

"Oh, okay," I say.

"I'm so tired," she repeats, " so, so tired." She starts to sniffle.

"Mom, if you want to live, that's great, " I try again, "but remember that Susie and I will be okay if you pass on. We'll be okay."

"You will?"

"Yes."

"I'm not in the mood to die," she says at last.

She looks vacant, pale, rigid and collapsed all at once. She also looks good to me because she is still here, and she is my mother, or sort of my mother.

"Well, " I say, "then let's have some lunch. I'll be right back."

I go to her little bathroom, throw some cold water on my face, then get her lunch tray. A large cheerful-looking African woman hands it to me—how is it, I wonder, that a large cheerful-looking African woman is handing me my mother's mushy food? It all seems so unlikely, absurd.

I set it up in front of her, all pureed and arranged: the magenta of beets, the white of potatoes, the lovely apricot color of peaches, the red/orange of tomato soup. I tuck the

towel under the neck of her shirt and begin feeding her. The colors astonish me as I keep cramming magenta and white and apricot and red/orange between her tight lips. As I wipe her mouth with the white towel, streaks of color in random patterns stain it. I lift spoonful after spoonful until I'm utterly bored. Sometimes she forgets to swallow, and swishes the food inside her mouth as if it's mouthwash. Sometimes she swallows. She's in food land. She's as hungry as a wolf. She eats and eats. This is not the behavior of a very sick woman, and I'm tired of feeding her, tired of the whole process, the shifting up's and down's of her decline. "Forgive me, Mom," I want to say. But I don't. I don't want to talk to her anymore. I want out.

At last. She's done.

"Enough?" I ask, and she nods.

I put *Fiddler on the Roof* on the VCR and move her chair smack up close to it. She doesn't notice when I leave.

At the Chinese restaurant around the corner from the nursing home, I wait for my shrimp and asparagus to go. I am sitting next to a table containing some magazines and a tall blossoming peach colored amaryllis. Beside it, is another pot with a long slender stem supporting what must have once been flowers. They are now small green balls, like something you'd see at the end of a Martian's antenna. How weird. The woman waiting for her order as she sits across from me is pretty and stylishly dressed in a black suit. Her brown hair shines. I'm reading about the death of Deng Chao Ping on the cover of *Newsweek*. I'm looking at pictures of him when he was young, when he was old, of how small he stood beside the great Mao tse Tung. The Chinese waiter tells the pretty woman that the asparagus and shrimp are ready.

She turns from him and asks me, "Did you order asparagus and shrimp?"

I nod.

"It's ready," she says.

I pay for my lunch and put it beside me on the front seat of my car. I drive home, then eat in front of the window as the

finches help themselves to seed in the feeder just outside. It is March and it is snowing. My mother is dying, and my mother is not dying. The asparagus tastes great. I haven't had asparagus for a long time. The color of asparagus is a deep and beautiful green.

<div align="center">⧸38⧹</div>

I receive a phone call from the nursing home saying that Mary Magee has died.

"Good for her," I think; what I say is, "That's too bad." Mary has been looking dead for well over a year. She's been a Hospice patient. Her son told me a week ago in the supermarket that he can't believe she's still alive, "It seems so cruel the way they keep them going," he said. But she did go. At last.

"Is Ruth okay?" I ask the nurse.

"We told her."

"Was she upset?" Mary has been her roommate for well over a year now.

"No, she's fine."

Of course, she's fine, I think, she doesn't get it. But perhaps, in some animal way, she will sense Mary's absence. Maybe not.

The next day I visit. A new body with a face is already in Mary's bed.

"Hello," I say. The woman doesn't answer, but smiles. I learn later that she's stone deaf. Mom seems equally deaf when I greet her.

It's Passover and so I've brought over some sweet heavy wine, matzoh, and a Haggadah, the ritual story of the holiday.

"It's Passover," I announce.

One of the nurse's aides enters the room. It's Jane, the one into Native Americana—eagle t-shirts, turquoise and silver earrings.

"Hi," I say.

She smiles as she approaches with a stark white Styrofoam cup of water for Ruth.

"Can you tell me how Mary died?" I ask, gesturing towards Mary's half of the room.

Jane stops dead in her tracks. Her mouth drops. She puts the cup on top of the television and bursts into tears. "Oh my God," she says, and runs out of the room. I rush out after her.

"I'm so sorry," I say, patting her shoulder.

"I didn't know," she says. She's biting her lip, facing the wallpapered wall. "I can't believe I'm reacting this way," she stammers.

"You mean no one told you?"

She shakes her head, "I thought Mary was in the bed," she says, "I just came on."

"I'm so sorry," I repeat.

"It's not your fault," Jane says. Then another aide joins us. She reports that Mary died peacefully after she'd been taken outside briefly in the morning for some fresh air. "She just stopped breathing," this aide explains, then adds, "she'd been really kept alive by *Ensure* for a long time."

"I hate that stuff," Jane says, "I never make them drink it, like some of the other aides do."

Back into the room. Mom's staring off into nothing at all. I get all breezy. And Jewish. "Let's have our own little seder, okay?" I chirp.

Mom stares at me, then slowly says okay. I get out the Manischewitz. It's left over from last year, thick and sweet and utterly purple. I pour some into another Styrofoam cup. "I'll tell you the story, Mom, like we used to at seder, okay?"

"Okay."

I tell her about Pharaoh and how the Jews were slaves in Egypt until God sent the plagues and the sea parted and we got the hell out of there. I remind her of the custom of sticking our little fingers, our pinkies, in the wine and taking out a

drop for each of the plagues which the Lord, blessed be His name, visited upon the Egyptians so they'd get fed up and let us go. The little drops that represent compassion, a diminishing of our own joy. "Let's say them together, okay?" I ask.

"Okay."

She still has one good hand, but I see it's really not good enough for this ritual because she can't extend her baby finger.

"I'll do it," I say, " but we'll say the name of the plague together, okay? Are you ready?"

"Frogs," I say, "we'll say *frogs*. Frogs. One-two-three—" slowly, I say FROGS."

She's eyeing me like a watch dog. She says nothing.

"Mom......FROGS," I say.

Nothing.

"You can do it, I know you can, say...." I clutch her eyes with mine, exaggerate my lips, FROGS.

Nothing. I do it again, "Ready, Mom? FROGS! You can do it, let's try, ready? NOW...."

"FROGS" she croaks with me at last, and we both laugh and laugh.

"Now, locusts." I say LOCUSTS very, very slowly—"L-O-C-U-S-T-S"

She just stares as I give up on her and name the plagues by myself until there are nine drops of bloody looking wine on a white tissue in front of my mother. Then I tell her how I hate the one about slaying of the firstborn. "Can you imagine killing a baby, even if you are God? Isn't it awful?" I ask.

She nods. I notice that my pinkie is stained purple. I look up and see Mom's face, pale and open. She smiles and we swim in a calm Red Sea together, our own momentary taste of another kind of freedom.

Nefish, she says.

"What?" I ask her.

It's warm and she, Bill and I are sitting outside the nursing home. She's wearing a white dress with black trim, short white socks and sneakers. Her hair is almost to her shoulders. I need to schedule a cut for her. She looks like an immigrant— her thinness, the outfit, her overgrown hair, the funky crocheted afghan Bill has covered her legs with.

Nefish, she says again.

"What does *nefish* mean?" I ask her, putting my face in front of hers.

She stares at me, mute.

"Mom," I persist, "tell me what *nefish* means. I know the word *nebbish,* but what is *nefish*?"

Nefish, she says. Mom doesn't know Hebrew, except for prayers and songs. It must be a Yiddish word.

"Mom, you know what?"

She shrugs.

"You'll be eighty years old this summer."

She gasps dramatically.

"Really," I say.

"She's the same age as J.F.K. would have been," Bill offers.

I try to compute this.

"Eighty, Mom. Isn't that something?"

She nods and smiles a milky smile. Today she's all eyes for Bill as he holds her hand. She's in her wheelchair across from where we sit on a wooden park-like bench. It is June, the trees deeply green. A big barrel is sprouting lavender. I pick a sprig and crush it in my hand, releasing the familiar spice and purple odor.

"Smell, " I tell her.

She sniffs.

Nefish, she says, looking at Bill. He smiles at her deeply. He's a good one.

Then a cloud goes across her face, she pauses, then clearly says to him, "I heard your death has dreams."

"Excuse me?" he says. He's also a polite one.

She stares at him, her mouth shut.

"I got it Bill," I say, and get out a little notebook and write down her words: *I heard your death has dreams."*

"That's a good one," Bill says.

"She's like an oracle," I say.

Nefish, she says once more, her eyes stay fixed on Bill.

"She likes you better than me," I chide.

He laughs. "She does not. She's just fixed on me today."

"You like men," I say to Mom.

"You shameless hussy," Bill adds, and we all laugh.

We bring Ruth back to her room. Polly, her new deaf roommate is sitting in a chair beside her bed. She tells us she is ninety-six, she loves it here and Ruth is a lovely woman. She says she has trouble hearing and seeing. I put my face in front of hers and shout, "I'm Genie, Ruth's daughter."

"What?" she asks.

I scream again, "I'm Genie, Ruth's daughter, and this is Bill, my husband!"

Bill comes forward and shakes her hand as I open the windows.

"That breeze is just lovely, a lovely spring breeze," Polly says.

"Yes," I shout.

There is a huge clock behind her on the wall, the kind you'd see in a high school classroom, the kind you'd stare at, wishing time would fly.

Polly says, "I love to see the time, but that clock is in a terrible place."

"Where would you like it?" Bill screams.

"Where I can see it all the time."

Bill and I begin moving things around the little room, and then I nail the clock across from where Polly sits, on the wall beside the television.

She grins ear to ear, thanking us. "I love to see the time," she repeats, "I just love it." She's aglow. "And that breeze, it's so nice here. And your mother, she's so nice."

Ruthie is sitting mute and stiff in her chair. She's somewhere else entirely, someplace where time is irrelevant. She reminds me of that scary carved coconut I had as a kid. An Indian with a large nose, a stern impassive mouth, an icon of angry resignation, which I associated somehow with my Dad.

Polly stares at the clock happily.

"Mom," I say, "do you want to see *Fiddler on the Roof?*"

She nods.

"Okay." Then for the two hundredth time Topol is back in the nursing home on top of that godforsaken roof fiddling as the sun comes up. Ruth stares. Polly smiles at the TV, or at the clock, I can't tell which. As we leave, I hear the fiddle resonating down the hall, an eastern European heart sound.

"Is it too loud?" I ask Chris, the nurse at her station.

"Oh, no," she says.

Three familiar looking residents are slumped in chair across from her. One clasps her doll with a pink bonnet to her chest.

"You sure?" I ask Chris.

"It's fine."

The next day I call the Rabbi. "My Mom keeps saying the word *nefish,* what does it mean? Is it Yiddish?"

"No," he says, " Hebrew. It's the Hebrew word for *soul.*"

I just wish she'd fuckin' die," I find myself saying to Bill.
Who is saying such a thing? It can't be me, Ruth
Zeiger's daughter would never say, "I wish she would die," no
less "I just wish she would *fuckin'* die." But this is exactly how
I feel after this particular visit.

She's in her room in her wheelchair. It takes her at least
five seconds to send the message from her eyes to her brain
and then to her face in order to show any recognition of me.
Then there it is. Not words this time, but a smile and tearing
eyes. I bend to hug and kiss her, she kisses me, then the mask
returns. She stares off towards the TV, which is off, and then
rotates her head slowly back towards where I'm standing. Polly
sits in her chair facing the clock she loves to watch, but she's
asleep.

"Would you like to go out, Mom?" I ask.

She nods. I get her sunglasses on. "It's really hot," I say,
"but you're used to that from Florida." But she has no idea
what Florida is—it could be a new continent, a kind of hat.

Out we go. I find some shade and sit on a bench across
from her, but she isn't there, no one's home. Cute in her white
dress with the black polka dots, cute in her little white socks
and sneakers. Her legs are particularly frozen, and her feet,
dangling from them, are awkwardly positioned on the foot
rests.

I try to be Zen, to just simply sit in the silence and hold
her hand, but it is hot and boring and today I can find no com-
passion. Her body is here, but she is isn't. I came to see her
because I missed her, and now I miss her even more. I put my
face on her hand and begin to cry. She doesn't notice. She
stares towards the road beyond the nursing home, then slowly
turns toward me in slow motion. I stop crying.

I should try to make her happy, but I don't' know how
anymore, and all she does now is make me unhappy.

"Do you know where you are?" I ask her.

She shakes her head no. She's been in this goddamn nursing home for more than two years.

"Do you want to know?"

"Do you want to tell me?" she asks slowly.

"Not really," I say. I laugh, sort of.

Another long pause and she's again staring at the road.

"Do you want me to tell you the story of your life?"

"Okay."

I tell her the short version—where and when she was born, parents' names, a chronology of the major events leading to now. It doesn't sound bad at all.

"You had a good life," I conclude, "you've lived a lot longer than your parents and sister. You're almost eighty, that's how old Daddy was when he died. Do you remember him?"

"Yes," she says.

"Do you want to keep living?" There I go again, it's awful. I keep thinking that if she says no, I'll fly her out of here, not feed her, be with her as she dies in about a week, and may we all rest in peace.

"Yes," she says.

I want her to say *no*, instead of this interminable *yes*. She looks like shit. She must be divorced from bodily pain because although she looks tortured, whenever I ask, she says she doesn't hurt.

"Let's walk. Do you want to see some flowers?"

I wheel her in the ninety degree heat up the street toward a yard with bold pink rhododendron blooms. Her head is now fallen back like a baby bird's; she is looking up.

"Ma, look this way, at the flowers."

She doesn't.

"Are you okay?"

"I'm okay."

"Look Mom, just put your chin down toward your chest." Nothing.

I decide we'd better go back. She looks dead. I try to cradle the back of her head with my midriff as I wheel her back to the home. People in passing cars stare.

The social worker, who's in the lobby when we arrive, looks at her and asks what's wrong.

I tell her I don't know, I just can't get her to raise her head.

"I've never seen her like this before. I'll call the nurses and alert them."

She's immediately put to bed. Two aides lift her and I see that her body can't change from its almost fetal position at all now. They take off her wet diaper and wash her. Her face is flushed and I put a cold compress on her forehead and try to give her water, which she pockets. "Swallow," I say, "swallow it." Slowly she gets a little down.

I usually go out when the aides attend her, but I don't care what I see anymore. I don't care about a goddamn thing. I don't care about the names of all the birds I've been trying to learn this spring, or the names of the wildflowers. I want my mother, not all this beauty around me.

I leave furious, and with a furious headache. I do errands, things I've been putting off doing because they're dull, but I'm happy to be doing them now: washing the car, picking up the knives that have been sharpened, getting the groceries. After I get home, I take a walk hoping to get rid of my headache, marching past flowers whose names I don't remember and stupid beautiful birds. The one on the phone wire, with the white strip at the end of its tail, I think is a kingbird, but who cares?

❧ 41 ❧

All I can do is let her go, let the world be big enough so that her departure, such as it is, fits in. She is mostly in another realm of being now, and she is okay there, okay in spite of how she looks and acts here. For her, there is no future and no past, there is only the now of sleep, the now of staring,

of trembling, of being lifted or put down, of being washed, fed, the now of a cup, of a spoon, of a face appearing and disappearing. What I see as wrong with her is all infused with my needs, wanting my mother to look and act in the ways I have known as real.

Death is not the enemy, fear is. How will I live without her? Am I looking at myself in twenty-five years?

The body must be a garment; spirit must exist before that garment is put on, and survive after it is taken. I think of Mom's gray Persian lamb coat. I remember how the furrier altered the collars, hems and waist lines to suit the inconstant styles, how every few years Mom would wrap herself in the transformed fur, then twirl slowly on the living room rug displaying its new incarnation.

My mother will, I know, live in me always. But this is not enough. As I sit with her, I keep wanting her in the old ways—with more flesh, words, smiles; I want her giving something instead of this damn staring off into space.

"Who is this?" I ask her, showing her a large color photo of me and my sister.

"They are beautiful," she says, her eyes misting.

"Do you know who they are?"

"No," she says.

She is shriveling into the future, backing up into death, and before she's gone I'd like again to sit with her for long stretches and not freak out—antsy, bored, or furious. Not feel betrayed. I don't know if I am big enough to do this. What keeps getting bigger, instead of me, is this work, this book. Because she is the words. Her death is writing it, and I transcribe. I believe I am done with it, and then I press on. Whenever I feel I've captured her just where she is, as a painter with a portrait, she moves and I must extend my reach, rework my strokes, thicken my story until I hold everything in it, even the most intolerable, until I hold all of myself in it, and say *okay*.

She hauls me, as if I were a fish, out from each water I have known and found safety in, then drops me into a larger place where I grieve and rage. Then she demands that I accept

with grace *that* place. She makes me outgrow the needs of my ego, as I did the clothing I outgrew naturally as a child. Then she would simply buy me larger sizes, bigger fits, blouses, skirts, pants, shorts, shoes, all with a bit of room, "so you can grow into them," she'd say. How I loved those new dresses with the white collars, the checkered coat with shiny buttons, the gleaming black patent leather of my Mary Jane's, the white white of new Keds.

I must expand into the absences she leaves me, enter them crawling and singing, fill those voids with myself and the things of a world which, as it retreats, grows more and more dear. I must accept her final gift, that of her departure.

≈ 42 ≈

I write this with sunlight streaming in my room and onto the page. Always I am drawn to the sun. Did such passion begin when my mother placed me under a sun lamp on a soft faded pale blue towel on a card table in a dark apartment in Brooklyn? I remember light and heat, the gooseneck lamp, the exact placement of that table at the end of a long dark hall, just before the entrance to the kitchen; I remember her warm hands in the light.

Chris has called to say Ruth has pneumonia, "I'd give her two weeks at most," she said, "I'm sorry."

I am surprised and I am not. I'm afraid it is the end, and I'm afraid it is not. I call my sister, then rush to the Buckley. Mom is pale and coughing. She does not speak. There is fear in her eyes. She lies small in her bed and I sit beside her. Her hand is thin and warm. She has a bit of a fever. I talk to her, I sing, read psalms. None of this is unusual, although it feels so.

Susie arrives and we take turns sitting with Ruth. Some days, we sit together. We come to know the sounds and rou-

tines of the nursing home thoroughly, including the law that residents must be offered food no matter what. Ruth has hardly eaten for three days. She can barely swallow. She takes small sucks of water from a small pink sponge attached to the end of a stick which we carefully try to insert between her tense jaws. She appears uninterested in everything but her fear. Our presence seems to mean nothing.

Dee, one of the aides, enters the room with a tray in her hands. "Would you like some breakfast?" she asks Ruth, who makes no response. Then Dee turns to us. "Sorry, she says, "but we have to ask."

Next day, day four since the prognosis, she stops drinking. "How long can someone go without food and drink?" I ask. "Usually three to five days," Chris says. We decide to call Hospice in again, for extra support. Even though it is a Sunday morning, Janice, the nurse, arrives within a few hours. We sign on; Hospice will provide supplementary care—a nurse and a social worker will visit daily. I talk to Janice about the fear I see in Mom's eyes, and inquire about morphine.

As soon as it is administered, the tension leaves, her vigilance ceases.

"It's a god," I say to Susie.

Ruth's jaw, which had rigidly tightened and quivered for years, is now relaxed; it hangs slack. She closes her eyes. For her, the next six days will consist of morphine shots at regular intervals (before which every nurse will say, "I'm sorry Ruth, but this may hurt for a second"). It will consist of being turned every four hours to prevent bed sores. It will consist of her daughters reading and singing to her through the long days of light, her hand in one of ours.

She's breathing here in this bed, inhaling and exhaling, her mouth gaping, but I don't know where she is. The sun rises and we arrive, it sets and we leave, telling the night nurses to call if anything changes.

Night time, day seven, Joanne calls at eleven PM and says it might be close, but she isn't sure.

"What's different?" I ask.

"Her breathing pattern changed," Joanne says, "but now it's evened out."

"I'm really tired," I tell her, "please call if things change," and then I lie awake most of the night.

The next day I arrive early; the Hospice social worker, the nurses and aides are in and out. It's a flurry of activity clustered about a woman doing nothing but breathing.

On the other side of the curtain to Mom's half of the room sits Polly. We've been talking to her in between rounds with Mom. Clearly all this activity is beginning to get to her. Although mostly blind and deaf, Polly knows what's happening. She's met our whole family this week—my kids, my husband again, my sister's kids and husband, some of our friends. Everyone's coming and going. I remember how, when we first met, Polly told me she's alone, there's no one left.

For more than a week now, she has had to sit or sleep in a room in which Ruth is dying. She stares at the clock, which we put up on the wall for her, she calls out to us. Susie and I spend more and more time with her too, buying her donuts and a single beer, "a treat," which she requests. We hug her, introduce her around again and again. But always we return to Mom with a vengeance.

Day number eight. Afternoon and uncommonly quiet. I have to avert my face from Mom's now because of the odor rising from her open mouth. She is peaceful. There is a thin, palpable thread, and it is called *breath*. I am surprised at how entirely comfortable I am with her now; I've never sat with a dying person before. *I've seen this over and over*, I think, *this is perfectly normal.* I feel strong and present, as I would reaching a still body of water after a long hike through the woods to it. This has been a really, really long hike....

Susie comes in. "I know this is weird," she says," but I want to sing *You'll Never Walk Alone* for Mom, will you sing it with me?"

We've been singing a lot lately, especially Susie—Hebrew songs, Sinatra, show tunes. I prefer to read prayers and psalms,

but now we're here together. We stand beside her, holding hands as we did as kids in all those snapshots.

"Let's pull the curtains all around," I interrupt giggling, "I don't want all the world to see us." There's the metallic jiggle of the curtain on its track, then I rejoin Susie and we sing from *Carousel.*

"My turn," I say." I read the twenty-third psalm, and a Buddhist Bardo prayer for clear travel between the realms of life and death. Then silence.

A nurse we don't know comes in, and introduces herself as Claire.

"I just want to say goodbye to your mother," she says.

"Of course." We move aside as Claire goes up to Mom and kisses her on the forehead. "You are a good woman," she says in her ear, "a very good woman." She begins to cry, then stops herself. "You know," she says to us, "your Mom never complained, she was great. Sometimes I'd wheel a patient who was agitated next to her because her presence was so calming."

The next day, the ninth of the vigil, the fifth of no food and no drink, Susie and I continue to take turns reading, singing, sitting quietly or talking to her. Take turns curling up at Mom's feet at the bottom of her bed trying to nap, talking to Polly, to each other. The sun enters the room in late afternoon. Susie begins to shut the curtain. "Let it rest on her," I ask, "it doesn't bother her, her eyes are shut."

"Mom sure is a tough one," Susie says, staring at her.

Yet there's a way in which each day takes a little more away. Her skin lies down flatter on her face, her eyes sink a bit more, there's less color. "Will she ever die?" I whisper, "I can't believe she's still alive, but it's Ruth."

Susie keeps talking to the nurses, asking them what they think, how long will it be? Ernie, the night nurse, says it's all in the ears, "they curl backwards." And so we keep checking her ears, but they look pretty much the same. Then they begin to turn a little blue. "What about blue?" Susie asks me.

"Ernie said *flat*, not *blue.* Remember?"

"But you told me your dental hygienist's father got blue," she contends.

"Yes, but that was over the top of his head, not his ears."

"Do you think she'll ever die?" she whispers hours later. We know that hearing is the last sense to leave, and so even now we're careful about what we say in her presence, which seems only that of shell and breath, the meticulous metronome of in and out, raspy, but unerringly regular.

Day six without food or drink. I wonder if it is a world record. We decide to stay home, we're beat. We ask to be called if anything changes. We stay around my house. Susie reads, I putter in the garden. It's August, two weeks short of Ruth's eightieth birthday. I call the nursing home late afternoon and ask how it's going; it's the same. "We'll be there after supper, around seven," I say.

My daughter is preparing a special meal, Pad Thai, which she learned to make from a friend, an Asian chef. She's been working at it for an hour. I get antsy, thinking I should go to Ruth, but I don't want to disappoint Mara, change my plans. I do that too often. Just before we sit down, I call and get Claire this time.

"You're on third floor tonight?" I ask, surprised.

"Yes," she says.

"Good."

"How's Ruth?"

"I just went in to see her and I think it will be tonight. What I'm going to do is bring my paperwork into her room for a while."

"Thanks, we'll be there around seven." It is 6:15 as we sit down to eat.

"This is fabulous," I tell Mara. "Wow!" I mutter about every thirty seconds, "this tastes great!".

"I've never heard you so enthusiastic about eating," Mara says.

"Same here" echo Bill and Susie.

As I finish my second helping, the phone rings. It's Claire. "Your Mom just passed away." I sink to the floor. "Suddenly, I could see it was coming fast," she continues, her voice quick and cracking, "it was beautiful, I mean I was reading her a

psalm from the book you left beside the bed, number seventeen, it was perfect and the sun was streaming in through the window, like it does this time of day and it was on her face, I was reading to her and she died so peacefully, just stopped breathing. It was an honor to be with her. Thank you."

"Thank you," I say, "we'll be right over."

I hang up the phone, briefly tell the story, then begin to cry, thinking, *I wasn't there, I wasn't there.* I run outside, my daughter hates to see me upset. I hear Susie crying from inside.

In a few minutes, I realize that Mom chose this exit, that we'd given her every chance in the world to die with us present, we were planning to arrive in half an hour; she had to know. I remembered how in Hospice training we were told that people often die when family members leave the room; they don't want to pass on in their presence, it's too hard.

We all zoom to the nursing home. My son Josh arrives.

There lies Mom. The same, but not breathing. Peaceful. The absence of breath is astonishing. We kiss and stroke her. She is cooler already. We touch her forehead. Susie asks, "can we sing *Sunrise, Sunset?*" Mara leaves the room, "it's too much for me," she says, "I'm going home, I'm all right," she adds, "don't worry."

We sing from *Fiddler on the Roof*:

> *Sunrise, sunset*
> *Sunrise sunset*
> *Swiftly fly the years;*
> *One season following another,*
> *Laden with happiness and tears.*

Bill suggests a last Sinatra, and we do, "You Make Me Feel So Young." There's a sweet smile on his face.

Polly begins crying on the other side of the curtain, and Susie hurries to her.

"Please," Polly says, "Don't let me be here when the funeral director takes her away." We promise. Susie goes to the nurses' station and tells them Polly's wish as Polly tells me and

Bill what a nice woman Ruth was, what a nice family we are. I bend and hug her, Susie comes in and hugs her. Bill and I vow to visit Polly monthly. O my God, I immediately think, I'll have to come back to this place!

Mr. Wrisley, the local funeral director, whom we've hired to take care of Mom's body before it is shipped to Florida, arrives twenty minutes later, warm and consoling. Josh, visibly shaken, helps him lift Ruth into a big plastic zippered bag. It is burgundy with white trim. We kiss her again before she's tidily zipped up.

Polly has been taken to the TV room, and all the doors to all the rooms on the floor are closed as Mr. Wrisley, after hugging us all, wheels Mom to the hearse, Josh beside him, chatting. Later Josh will tell me, "I thought it was important to be there, to get to know death better." I hug him to me.

Psalm 17
Lord, listen to my prayer......
Cover me with your mercy,
* rock me to sleep in the dark.*
And let me, when I awaken,
* see nothing but the light of your face.*

43

There is a Jewish Burial Society in our county, and a few weeks before Mom's death, I called to inquire about their services. Phyllis, the woman in charge, told me that there is a custom, *Hevrah Kaddisha*, mostly of the orthodox, which involves the ritual washing of the dead. Men wash men; women, women. It is a voluntary service, and performing it is considered an honor. I ask if my mother can receive this rite even though she'll be buried in Florida, not in Massachusetts. Phyllis says yes.

"Can my sister and I be there?" I ask.

"I'm glad you brought that up," she says, "I've been doing this for twenty years, and now that my parents are failing, I've been thinking how I want to be present for my mother, when it's time."

"Well, why not?" I ask.

"A law of some kind... I'll check with Rabbi Rieser. It has to do with the indignity of a child seeing her parent naked.. but we do all the washing under a sheet."

Phylis calls the next day. "I spoke to the Rabbi, and he thinks it will be okay, but he has to check with Rhonda, his wife."

Next day we get the green light. Susie and I talk it over and decide to watch; we will read psalms aloud, which is part of the ritual.

"I don't think we'll actually participate with the body," I tell Phyllis.

"Whatever is comfortable for you," she says, "and I'm so glad you're coming."

"Me, too."

The morning after Mom's death, Susie and I arrive at the funeral home a few miles from town. Four women are already gathered outside the side door—Phyllis, Rhonda, Ellen and Karolka, all of whom I know from having lived in this community for more than twenty years. We join them. I'm clutching my book of psalms; a dress, which I've bought for Mom to be buried in, is draped over my right arm. It is fancy white silk, with large black polka dots and shoulder pads. Mom liked it, it looked good on her.

Rhonda asks that we hold hands.

"Here?" I ask, circling my eyes around the parking lot. Cars whizz by on nearby route five, a few kids on bikes skid past with garish helmets.

"Why not?" she asks, "it's a beautiful morning."

And it is, the trees in late full August green, the sky a dainty blue lid.

Rhonda suggests we close our eyes, focus, and breathe together. Then she asks that Susie or I tell them all something about our mother. Susie talks of Mom's achievements: the chiropractic degree, her B.A. and M.Ed. late in life, her becoming a teacher past the age of fifty, her community and charitable work. What a strong and determined person she was. I add the story of how Dom, the eight year old son of my friend Anna, responded to the news of Ruth's death. Knowing it had been a long and difficult one, he said, "Well, I hope she has fun in her next life, but I hope they let her rest a little before they make her go down again." We all smile as the kids pass by on their bikes again, this time staring at us.

"Perfect," Phyllis says nodding at them, smiling.

All things, I think, are heightened around death; events are clear, emblematic, related. Right now everything feels holy.

In silence we follow Rhonda inside and are directed by Mr. Wrisley downstairs to a small room in which the bodies are prepared for burial. There are cabinets, odd utensils and bottles of chemicals neatly arranged. Mom's body is laid out on a metal table in the center of the room. She looks a lot like yesterday, only more yellow and thin under the sheet.

We each wash our hands three times as instructed, left hand first, at the small porcelain sink at one end of the room. The four women put on rubber gloves, and a prayer is said: "...may it be thy will, our God, to give us courage and strength to properly perform this holy task of washing this woman's body and putting on the shroud, and burying her...."

Then Mom receives an apology: "Ruth, daughter of Miriam, we apologize for any indignity we may cause you in the performance of this procedure. Please forgive us and know we do this task with care and to honor you."

Another prayer is said before the actual washing begins, and this one asks that a circle of angels of mercy be brought before Ruth, that she be granted forgiveness and quick entry into the garden of Eden.

The pitchers are filled with water, "As it is said, and I will pour water and you will be purified from all your defilements and from your abominations I will purify you."

Three pitchers are poured on my mother's body and after each pouring we chant together, "*Tahorah He*; she is pure."

Susie and I, as planned, stand and read psalms intermittently at nods from Rhonda. Then the activity stops, and beside my mother's small, cold, long tortured body, Phyllis reads from the *Song of Songs*:

> *She is a rose of Sharon, a lily of the valley*
> *Her eyes are like doves behind her veil*
> *Her hair is like a flock of goats streaming down Mt.*
> *Gilead*
> *Her lips are like a crimson thread, her mouth is lovely*
> *Her neck is like the Tower of David, hung with a*
> *thousand shields*
> *Her breasts are like two fawns, twins of a gazelle*
> *Her limbs are an orchard of pomegranates*
> *Her rounded thighs are like jewels*
> *Every part of her is fair, there is no blemish in her*
> *She shines through like the dawn, beautiful as the*
> *moon, radiant as the sun*

I watch through my tears as the women begin to dress Ruth in white linen, reciting: "God has clothed me with the garments of salvation, Shechina, (the female aspect of God in Hebrew), will guide you continually and satisfy your soul in a time of drought and make strong your bones and you shall be like a watered garden, like a spring of water whose waters never fail."

Mom is slowly dressed. First the trousers, (it is hard to lift those rigid, bent legs). A band is tied four times about her waist, then adorned with four bows, a prayer said after the tying of each. Next a tunic, the bands again tied exactly. Then a linen headdress, the bottom of which covers her eyes, "to keep from being blinded by God's light," Rhonda whispers. An apron is placed around her neck, and Susie and I help lift her head so that a linen pillow can be placed under it. It is to be filled with earth from the land of Israel.

Finally Mom is wrapped in her full linen shroud. Again Susie and I find ourselves helping lift her as the women

swaddle the body until the cloth wraps all of her, even her face. Again there is an apology for any indignity caused her: "Please forgive us and know we do this task with care to honor you."

We stand in silence around her shrouded body. Then we again wash our hands three times, left hand first. I kiss the place where her head is, Susie does the same, then we leave her and go upstairs and stand together.

"I brought my Mom a dress," I say, "but I don't want her to wear it."

Everyone nods.

"How can we thank you?" Susie asks, looking at the women.

"How can we thank *you*?" someone says. Phyllis smiles, Rhonda solemnly nods, Ellen weeps, Karolka is red in the face.

Mr. Wrisley is happy to hold onto the dress, he tells us, "Some people don't even have enough money for something to be buried in; someday it will be put to good use."

Two days later, under the hot Florida sun, I watch my mother's plain wooden coffin being lowered into the ground beside my father's marble stone. The last thing I notice is a long piece of white linen thread caught between the lid and the body of the box. It waves delicately as my mother is, at long last, lowered down into the earth I love.

EPILOGUE

Watching my mother die was the hardest thing I've ever done. Initially, I wrote these words in order to survive, then I continued working on them so they might accompany other women through this difficult passage. I want to show that the depth of a daughter's grief is "normal," as is the possibility of redemption at the end.

It is now a year since my mother's death. For six weeks after her burial, I continued to feel her presence, as if she were an old helium balloon hanging, pale pink and bloated, near the ceiling. I consulted others, said prayers for her, even talked to her, urged her on. She was, it seemed, like a kid afraid to go to kindergarten. This initial period continued to be a time of digestive illness for me. Then, at last, one day she left as she had to, and the house felt free, clean, and open. Although I have always believed in the mind-body connection, I marvel at my recovered health, give thanks for the return of appetite and energy. The tearing apart between us, as with a difficult birth, seemed endlessly painful, but my mother's final departure gave me new life. The strong umbilicus that had bound my initial watery life with hers was at long last cut, and the raw places where we adhered, each to each, are largely healed.

In what I knew was a futile but nonetheless necessary attempt to prevent my own daughter possibly suffering with me, as I did with my mother, I wrote her a letter in which I explained that it is okay for her not to visit me if I end up in a nursing home (with two out of five Americans living in such homes, it is a distinct possibility). Please, I added, save this letter for future reference. She wrote back:

> Dear Mom: You may well not fade the way grandma did. I will always want to see you no matter what. I love you totally. Love, ME.

She may need to change her mind down the road. Everything changes, nothing's certain. Although Bill and I vowed

after Ruth's death to visit Polly in the nursing home, we never could get ourselves back there.

I am also confident that my generation, the vanguard of the baby boomers, will help to revolutionize, re-humanize the dying process, as we did the process of childbirth.

There is life after death as I feel myself adrift between the worlds of the young and the old, tilting toward old; between the worlds of sadness and joy, tilting towards joy. This joy is of the quiet sort, rooted in appreciation, this appreciation rooted in the absolute knowledge that my time here is limited. Losing a mother means losing the illusion of being protected from death.

Losing a mother also means feeling more alone. It has pressed me to rely more upon Bill for caring, to move closer emotionally to my own kids, to my sister and hers, to friends and community. And yet there it remains—a large empty space. As cliched as it may sound, no one loves you like your mother does, absolutely no one. The past, which included being someone's child and protected, is altered, and there is an abiding sense, at least intially, that this alteration is somehow "wrong." It's as if you once had a safe spot like "home" in hide'n'seek where no one could ever tag you, get you. But now it's gone, there's nowhere to hide, and you're it. But, if you are open to them, you may find there are mysterious, nurturing others.

One day, a few months after my mother's death, I looked out the kitchen window towards the woods, beyond the tree upon which the barred owl had repeatedly perched the year she died, and saw a giant figure in a white robe. She was angelic, ghostly and fierce. I know deep in myself I rest on her breast, which is that of the earth, and that her presence, and those of others like her, will grow more vivid as I move closer to my own end. Guardians, in some mysterious measure, begin to replace my mother, and I want to continue to welcome them in whatever form they assume, and to be unafraid. When my mother began singing *Shalom Aleichem* in the nursing home, what she was doing was welcoming *malakay ha shalom*,

the angels of peace. I believe now that the beginning of wisdom is not fear of the divine, as I was taught in religious school, but trust in it.

Before the ordeal of her dying and my illness, I often felt a great yearning for what we call god. I'd spent years practicing meditation and yoga, and reading books on spiritual subjects, particularly Judaism and Buddhism. But it was my mother's death—my trial by fire, my four years in the desert which her dying created—that surrounded me with the thin dry air through which I began to truly honor the divine.

All mothers die, of course, and in a way nothing drastic changed when she did, yet everything changed. An example: when I first wrote the draft for this epilogue, I found myself asking for help with it each night before I went to sleep, and I woke up in the middle of many nights with advice. One night, a voice said, "if you use the word redemption, (which I do at the end of the first paragraph), you'd better define it." "Who in her right mind would want to do that?" I thought. But I must try.

Redemption takes the form of an active relationship with the divine, which for me includes giving thanks each morning for a new day, and listing, before sleep, the pleasures I've received. I adapt old Hebrew prayers, dear to me because of their familiarity, and make up new ones. I say them before I eat, when I wash my hands. I cannot define clearly who or what I am addressing, but I live more at home with mystery. My god is not a Jewish god, it is far more earthy and female than the patriarch I was raised with; it is a god not imposed, but received.

Years ago, I read that Jung consciously chose to believe in a life after death because it made living easier, better. For me, the experience of my mother's death presented me with the gift of this belief: we don't just die and become nothing, (the fear that tormented me as a child). Whatever made my mother, outlives her and exists in me, my children, in memory. For nurturance, I go to her in imagination, and to her counterparts in the natural world. Although I still fear the journey

there, I know I will ultimately join her and luminous others in the end; I am confident about arrival.

We make and re-make our own worlds with images, and each image has its own soul. Over time, the image of my mother has been gratefully restored to that of the vital woman she was before her dying. I miss her most on Sundays, when she'd call, and on Friday evenings when I remember her standing dark haired and strong, lighting the candles. Or I might be cutting onions, my eyes tearing...or my son gets a new job, my daughter enters graduate school.... or there is a success in Bill's life or mine, and I want to call her. Or it is spring and I see the same stand of daffodils from which I cut her a bouquet last year. But sometimes I talk to her, especially when there is danger or challenge, and she advises: be careful, don't do that, do this. She urges me to choose and commit fully to my choices, be it preparing a meal, making love, visiting with a friend.

With the purpose of exploring the impact of a mother's death in a broader way, I gathered a group of ten women to write and talk together. All of us are middle-aged and have lost our mothers in the past few years. One question I posed was, "How and when do you feel or not feel your mother's presence?" Many of us feel our mothers near when gardening or outdoors in nature where the cyclical—birth and rebirth— is visibly in process. Or when engaged in activities our mothers often performed—baking, sewing, easing a canceled stamp off an envelope. A few women, who had never been particularly close to their mothers, had little to report, but the majority of us did.

> One woman wrote, "I feel my mother's presence more keenly now than I think I did when she was alive, partly because I savor it and I am pleased for myself and for her when it happens. Although it is scary in many ways, I feel her most present when I do things she did: when I quote my children, when I tell a story badly, when I cannot, as she could not, pronounce a new word. She is most present when I open the drawer of my dresser (inherited from her),

and the drawer pull makes the special noise that is the same noise I heard for the first eighteen years of my life."

Another woman: "Although I am not the sort of person to say this, I feel that somehow she knows what's going on with me and our family, and that is comforting, but the power I attributed to her to make things go well is no longer there."

And another: "Sometimes when I think of her, I wonder where she went and how I could have missed her so much for nearly a year and now I don't miss her in that terrible gut wrenching, grieving way, but in a nicer way that means I don't think of it as grief now, but pleasure that she was my mother and maybe someday I'll know why I was born."

"Memory," St. Augustine said, "is a form of imagination." Recently, in a NASA photo, I was struck by the spiraling fetal shape of a vast and distant star field. It was, I read, the result of a collision of two galaxies, like the meeting of a vast sperm and egg, which led to a fire storm of star birth activity. Like the spiral forms of the galaxies themselves, the old curls in on itself and becomes new, as does the vegetation in the garden each fall. As did my mother's body; as will my own. My hope is that I accept this inevitability—in whatever form it takes and in spite of all that will be lost—with a vast amount of grace. As my mother did.

About the Author

Genie Zeiger lives with her husband, Bill Ennen, in western Massachusetts where she leads writing workshops. The

winner of a Massachusetts Cultural Council Award for poetry, she is the author of two collections of poems: *Sudden Dancing,* 1988 (Amherst Writers and Artists Press) and *Leaving Egypt,* 1995 (White Pine Press). Her poems, stories and essays have appeared in more than fifty magazines, including *The New York Times Book Review, The Massachusetts Review, The Georgia Review, Tikkun, The Agni Review,* and *The Sun,* to which she is a regular contributor. She has twice been nominated for a Pushcart prize and is the winner of numerous poetry and essay contests. In addition, she has been a regular contributor for National Public Radio and is the poetry editor for the Massachusetts' Audubon Society magazine, *Sanctuary.*

Portions of *How I Find Her: a mother's dying and a daughter's life* have been published in *The Sun,* issues 239 (11/95) and 256 (6/97), as well as in *Peregrine,* vol. XV, 1996. The title poem appeared in the winter 1997 issue of *The Georgia Review.*